Toothpicks and Logos

Toothpicks and Logos

Design in Everyday Life

JOHN HESKETT

OXFORD
UNIVERSITY PRESS

OXFORD

UNIVERSITY PRESS

Great Clarendon Street, Oxford OX2 6DP

Oxford University Press is a department of the University of Oxford.
It furthers the University's objective of excellence in research, scholarship,
and education by publishing worldwide in

Oxford New York

Auckland Bangkok Buenos Aires Cape Town Chennai
Dar es Salaam Delhi Hong Kong Istanbul Karachi Kolkata
Kuala Lumpur Madrid Melbourne Mexico City Mumbai Nairobi
São Paulo Shanghai Singapore Taipei Tokyo Toronto

and an associated company in Berlin

Oxford is a registered trade mark of Oxford University Press
in the UK and in certain other countries

Published in the United States
by Oxford University Press Inc., New York

British Library Cataloguing in Publication Data
Data available

Library of Congress Cataloging in Publication Data
Data available

ISBN 0–19–280321–2

10 9 8 7 6 5 4 3 2 1

Printed in Great Britain
on acid-free paper by
T.J. International Ltd., Padstow, Cornwall

To Pamela

Contents

List of illustrations

List of Illustrations

1 What is design?

One of the most curious features of the modern world is the manner is which design has been widely transformed into something banal and inconsequential. In contrast, I want to argue that, if considered seriously and used responsibly, design should be the crucial anvil on which the human environment, in all its detail, is shaped and constructed for the betterment and delight of all.

To suggest that design is a serious matter in that sense, however, is problematic. It runs counter to widespread media coverage assigning it to a lightweight, decorative role of little consequence: fun and entertaining—possibly; useful in a marginal manner—maybe; profitable in economic sectors dominated by rapid cycles of modishness and redundancy; but of no real substance in basic questions of existence.

Not surprisingly, in the absence of widespread agreement about its significance and value, much confusion surrounds design practice. In some subject areas, authors can assume common ground with readers; in an introduction to architecture or history, for example, although the precise degree of readers' knowledge might vary substantially, a reasonably accurate concept of what constitutes the subject can be relied on. Other subjects, such as nuclear physics, can be so esoteric that no such mutual

understanding exists and approaches from first principles become necessary.

Design sits uncomfortably between these two extremes. As a word it is common enough, but it is full of incongruities, has innumerable manifestations, and lacks boundaries that give clarity and definition. As a practice, design generates vast quantities of material, much of it ephemeral, only a small proportion of which has enduring quality.

Clearly, a substantial body of people exist who know something about design, or are interested in it, but little agreement will probably exist about exactly what is understood by the term. The most obvious reference point is fields such as fashion, interiors, packaging, or cars, in which concepts of form and style are transient and highly variable, dependent upon levels of individual taste in the absence of any fixed canons. These do indeed constitute a significant part of contemporary design practice, and are the subject of much commentary and a substantial proportion of advertising expenditure. Other points of emphasis might be on technical practice, or on the crafts. Although substantial, however, these are all facets of an underlying totality, and the parts should not be mistaken for the whole.

So how can design be understood in a meaningful, holistic sense? Beyond all the confusion created by the froth and bubble of advertising and publicity, beyond the visual pyrotechnics of vir-

tuoso designers seeking stardom, beyond the pronouncements of design gurus and the snake-oil salesmen of lifestyles, lies a simple truth. Design is one of the basic characteristics of what it is to be human, and an essential determinant of the quality of human life. It affects everyone in every detail of every aspect of what they do throughout each day. As such, it matters profoundly. Very few aspects of the material environment are incapable of improvement in some significant way by greater attention being paid to their design. Inadequate lighting, machines that are not user-friendly, badly formatted information, are just a few examples of bad design that create cumulative problems and tensions. It is therefore worth asking: if these things are a necessary part of our existence, why are they often done so badly? There is no simple answer. Cost factors are sometimes advanced in justification, but the margin between doing something well or badly can be exceedingly small, and cost factors can in fact be reduced by appropriate design inputs. The use of the term 'appropriate', however, is an important qualification. The spectrum of capabilities covered by the term 'design' requires that means be carefully adapted to ends. A solution to a practical problem which ignores all aspects of its use can be disastrous, as would, say, medical equipment if it were treated as a vehicle for individual expression of fashionable imagery.

This book is based on a belief that design matters profoundly

to us all in innumerable ways and represents an area of huge, underutilized potential in life. It sets out to explore some reasons why this is so and to suggest some possibilities of change. The intention is not to negate any aspect of the spectrum of activity covered by the term 'design', but to extend the spectrum of what is understood by the term; examine the breadth of design practice as it affects everyday life in a diversity of cultures. To do so, however, some ground clearing is necessary to cut through the confusion surrounding the subject.

Discussion of design is complicated by an initial problem presented by the word itself. 'Design' has so many levels of meaning that it is itself a source of confusion. It is rather like the word 'love', the meaning of which radically shifts dependent upon who is using it, to whom it is applied, and in what context. Consider, for example, the shifts of meaning when using the word 'design' in English, illustrated by a seemingly nonsensical sentence:

'Design is to design a design to produce a design.'

Yet every use of the word is grammatically correct. The first is a noun indicating a general concept of a field as a whole, as in: 'Design is important to the national economy'. The second is a verb, indicating action or process: 'She is commissioned to design a new kitchen blender'. The third is also a noun, meaning a concept or proposal: 'The design was presented to the client for

approval'. The final use is again a noun, indicating a finished product of some kind, the concept made actual: 'The new VW Beetle revives a classic design.'

Further confusion is caused by the wide spectrum of design practice and terminology. Consider, for example, the range of practice included under the rubric of design—to name just a few: craft design, industrial art, commercial art, engineering design, product design, graphic design, fashion design, and interactive design. In a weekly series called 'Designer Ireland' in its Irish Culture section, the Sunday Times of London publishes a brief, well-written analysis of a specific aspect of design. In a six-week period, during August and September 2000, the succession of subjects was: the insignia of the Garda Siochanna, the Irish national police; Louise Kennedy, a fashion designer; the Party Grill stove for outdoor cooking; the packaging for Carrolls Number One, a brand of cigarettes; Costelloe cutlery; and the corporate identity of Ryan Air, a low-cost airline. The range of subjects addressed in the whole series is even more bewildering in its diversity.

To that list can be added activities that appropriate the word 'design' to create an aura of competence, as in: hair design, nail design, floral design, and even funeral design. Why not hair engineering, or funeral architecture? Part of the reason why design can be used in this arbitrary manner is that it has never cohered into a unified profession, such as law, medicine, or architecture,

where a licence or similar qualification is required to practise, with standards established and protected by self-regulating institutions, and use of the professional descriptor limited to those who have gained admittance through regulated procedures. Instead, design has splintered into ever-greater subdivisions of practice without any overarching concept or organization, and so can be appropriated by anyone.

Discussion of design on a level that seeks a pattern in such confusion leads in two directions: first, defining generic patterns of activity underlying the proliferation, in order to establish some sense of structure and meaning; secondly, tracing these patterns through history to understand how and why the present confusion exists.

To address the first point: design, stripped to its essence, can be defined as the human capacity to shape and make our environment in ways without precedent in nature, to serve our needs and give meaning to our lives.

Understanding the scale and extent of this capacity can be tested by observing the environment in which anyone may be reading these lines—it might be while browsing in a bookstore, at home, in a library, in an office, on a train, and so on. The odds are that almost nothing in that environment will be completely natural—even plants will have been shaped and positioned by human intervention and, indeed, their genus may even be a considerable

modification of natural forms. The capacity to shape our world has now reached such a pitch that few aspects of the planet are left in pristine condition, and, on a detailed level, life is entirely conditioned by designed outcomes of one kind or another.

It is perhaps a statement of the obvious, but worth emphasizing, that the forms or structures of the immediate world we inhabit are overwhelmingly the outcome of human design. They are not inevitable or immutable and are open to examination and discussion. Whether executed well or badly (on whatever basis this is judged,) designs are not determined by technological processes, social structures, or economic systems, or any other objective source. They result from the decisions and choices of human beings. While the influence of context and circumstance may be considerable, the human factor is present in decisions taken at all levels in design practice.

With choice comes responsibility. Choice implies alternatives in how ends can be achieved, for what purposes, and for whose advantage. It means that design is not only about initial decisions or concepts by designers, but also about how these are implemented and by what means we can evaluate their effect or benefit.

The capacity to design, in short, is in innumerable ways at the very core of our existence as a species. No other creatures on the planet have this same capacity. It enables us to construct our habitat in unique ways, without which we would be unable to distin-

guish civilization from nature. Design matters because, together with language, it is a defining characteristic of what it is to be human, which puts it on a level far beyond the trivial.

This basic capacity can, of course, be manifested in a huge diversity of ways, some of which have become specialized activities in their own right, such as architecture, civil engineering, landscape architecture, and fashion design. To give some focus in a short volume, the emphasis here will be on the two- and three-dimensional aspects of everyday life—in other words, the objects, communications, environments, and systems that surround people at home and at work, at leisure and at prayer, on the streets, in public spaces, and when travelling. Even within this focus, the range is still huge and we need only examine a limited range of examples, rather than attempting a compressed coverage of the whole.

If this human capacity for design is manifested in so many ways, how can we understand this diversity? This brings us back to the second point mentioned above: design's historical development. Design is sometimes explained as a subdivision of art historical narratives emphasizing a neat chronological succession of movements and styles, with new manifestations replacing what went before. The history of design, however, can be described more appropriately as a process of layering, in which new developments are added over time to what already exists. This layering, more-

over, is not just a process of accumulation or aggregation, but a dynamic interaction in which each new innovative stage changes the role, significance, and function of what survives. For example, innumerable crafts around the world have been widely displaced by industrial manufactures from their central role in cultures and economies, but have also found new roles, such as providing goods for the tourist trade or supplying the particular global market segment known as Arts and Crafts. Rapid developments in computers and information technology are not only creating exciting new possibilities in interactive design, but are also transforming the ways in which products and services are conceived and produced, in ways that supplement, rather than replace, the old.

Neither is it possible to describe a process with an essential pattern followed everywhere. There are significant variations in how the process of change occurs in different societies and also in the specific consequences change entails. Whatever the exact details, however, there is a widespread pattern for what existed before to continue in some form. It is this that helps explain much of the dense and complex texture of design, and the varied modes of practice under the rubric that confront us today. To ancient crafts and forms that survive and adapt are continually added new competencies and applications. A great deal of confusion in understanding design, therefore, stems from this pattern of historical

evolution. What is confusing, however, can also be regarded as a rich and adaptable resource, provided that a framework exists enabling the diversity to be comprehended. A brief outline of the historical development of designing—that is, the practice and activity of creating forms—is therefore necessary.

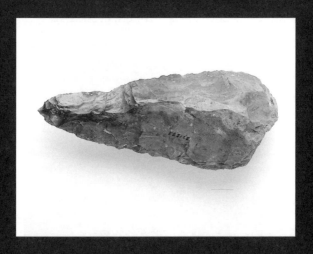

2 The Historical Evolution of Design

There has been change and evolution on multiple levels throughout the history of mankind, but human nature has remained remarkably unaltered. We are much the same kind of people who inhabited ancient China, Sumeria, or Egypt. It is easy for us to identity with human dilemmas represented in widely different sources, such as Greek tragedy or Norse sagas.

The evidence too is that the human capacity to design has remained constant, although its means and methods have altered, parallel to technological, organizational, and cultural changes. The argument here, therefore, is that design, although a unique and unchanging human capability, has manifested itself in a variety of ways through history.

Any brief description of such a diverse spectrum of practice must inevitably be an outline, using broad brushstrokes and avoiding becoming enmeshed in detail, with the intention of indicating major changes that have occurred in order to understand the resultant complexity existing today.

An initial problem in delving into the origins of the human capacity to design is the difficulty in determining exactly where and when human beings first began to change their environment to a significant degree—it engenders continual debate that shifts

with each major archaeological discovery. It is clear, however, that in this process a crucial instrument was the human hand, which is a remarkably flexible and versatile limb, capable of varying configurations and functions. It can push, or pull, exerting power with considerable strength or fine control; among its capabilities, it can grasp, cup, clench, knead, press, pat, chop, poke, punch, claw, or stroke, and so on. In their origins, tools were undoubtedly extensions of these functions of the hand, increasing their power, delicacy, and subtlety.

From a broad range of early cultures, extending back to about a million years, natural objects began to be used as tools and implements to supplement or enhance the capacities of the hand. For example, the hand is capable of clawing soil to dig out an edible root, but a digging stick or clam shell is also capable of being grasped to do the job more easily, in a sustainable manner, reducing damage to fingers and nails. The task is made easier still if a shell is lashed with hide or fibre at a right angle to the end of a stick, to make a simple hoe. It can then be used more effectively in wider circles from an erect working position. Similarly, the hand can be cupped in order to drink water, but a deep shell forms the same shape permanently and more effectively to function without leakage as a dipper. Even at this level, the process of adaptation involves the capacity of the human brain to understand the relationship between forms and functions.

In these, and innumerable other ways, the natural world provided a diverse source of available, pre-existing materials and models, full of potential for adaptation to the solution of problems. Once adapted, however, a further problem emerged, such as how to make a hoe more durable, less fragile, and less liable to fracture than a seashell. Another dimension set in, beyond simply adapting what was available in ready-made form—that of transforming natural materials into forms without precedent in nature.

Another feature of much early innovation was the adaptation of techniques, forms, and patterns to new purposes and applications. An example was seen in the discovery in 1993 at an archaeological dig at Cayonu, a prehistoric agricultural village site in southern Turkey, of what is believed to be the oldest textile fragment extant, dating from around 7000 BC. The fragment was of linen cloth woven from domesticated flax, and the weave was clearly an adaptation of pre-existing basket-weaving techniques.

Other continuities are also clearly evident. Frequently, natural forms continued to be the ideal model for a particular purpose, with early artefacts made from metal or clay often shaped in forms identical to the natural models from which they originated, such as dippers being made of metal in the form of conch shells.

Humans, from earliest times, have created stereotypes of forms, fixed concepts of what forms are appropriate for particular purposes, as a counterpoint to their contrasting capacity for

innovation. Indeed, forms frequently became so closely adapted to the needs of societies that they became interwoven with a way of life, an integral element of its traditions. In circumstances where life was precarious and people were highly vulnerable, the accumulated experience embodied in and represented by such forms was not lightly abandoned.

Nevertheless, over time, forms were adapted by intent or by accident, became refined, or were transformed by new technological possibilities, and new stereotypes would emerge to be adopted as a standard. These in turn would be adapted to specific local circumstances. In West Greenland, for example, each major Eskimo settlement had different versions of sea-going kayaks.

Emphasizing manual dexterity as a dominant feature of the crafts tends to underestimate two other developments crucial to enhancing human ability to transform an environment. Each represents a capacity to reach beyond innate human limitations. One was harnessing natural forces, the superior physical strength of animals and resources such as wind and water, to provide a supplemental level of power greater than the human body, and selecting superior strains of plants and animals for cultivation to provide greater yields. This required a process of enquiry and the accumulation of knowledge and understanding that could be applied to processes of improvement, in which writing and visual representation played a crucial role.

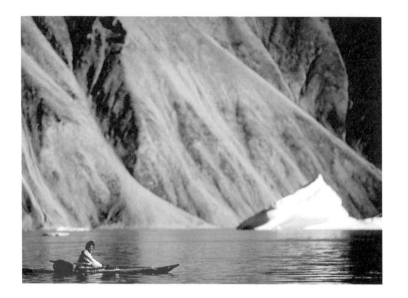

1. Greenland Eskimo kayak

Linked to this, and, in the long run, of increasing significance, was the ability to move beyond an accumulation of pragmatic experience into the realm of ideas as abstractions, with the evolution of tools moving beyond their origins in nature, to forms that were totally new and uniquely human in origin. Abstraction enables capacities to be separated from specific problems, to be generalized, and flexibly adapted to other problems.

Perhaps the greatest example of abstraction is language. Words have no innate meaning in themselves and are arbitrary in their application. For example, the words house, maison, and casa, in English, French, and Italian respectively, all refer to the same physical reality of a human dwelling and take on meaning only by tacit agreement within their society. The capacity to abstract into language, above all, allows ideas, knowledge, processes, and values to be accumulated, preserved, and transmitted to subsequent generations. It is also an integral element in understanding any process of making. In other words, mental skills and thought processes—the ability to use 'mind tools', which represent and articulate concepts of what might be—are as essential in any productive process as the physical skills of the hand and its tools, such as hammer, axe, or chisel.

In terms of design, abstraction has also led to inventions that are purely cultural, with no reference point in human physical form or motor skills, or in nature. Many concepts of geometric

form probably derived from accumulated experience in practical work, before being codified and, in turn, fed back into other applications. The evolution of spear-throwers, such as the woomera of Australian aborigines, represents such an abstraction. It gave much greater power and accuracy in hunting and must have evolved in a long process of trial and error. The form of the wheel, however, has no immediately discernible precedent —human limbs cannot rotate upon their own axis and possible stimuli in nature are rare. The concept of infinite rotation is therefore an innovation without precedent. In other words, objects are not just expressions of a solution to a particular problem at any point in time, but can extend much further, into embodying ideas about how life can be lived in a dynamic process of innovation and refinement beyond the constraints of time and place.

Therefore, neither the hand alone, nor the hand allied to the other human senses, can be viewed as the source of design capability. Instead it is the hand allied to the senses and the mind that forms the coordinated trinity of powers by which human beings have asserted ever-greater control over the world. From the origins of human life, flexibility and adaptation resulted in a proliferation of means and ends, with individuals and societies adapting forms and processes to specific needs and circumstances.

Early human societies were nomadic, based on hunting and gathering, and, in a shifting pattern of life in search of new

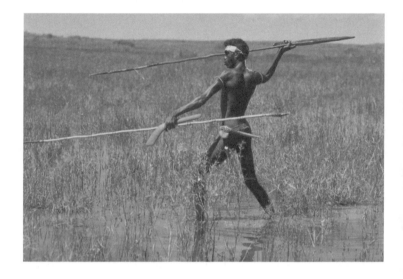

2. Simple weapons embodying technical sophistication: the
Australian aboriginal woomera

sources of food, qualities such as lightness, portability, and adaptability were dominant criteria. With the evolution of more settled rural societies based on agriculture, other characteristics, other traditions of form appropriate to the new patterns of life, rapidly emerged. It must be emphasized, however, that tradition was not static, but constantly subject to minute variations appropriate to people and their circumstances. Although traditional forms encapsulated the experience of social groups, specific manifestations could be adapted in various minute and subtle ways to suit individual users' needs. A scythe or a chair could keep its basic, accepted characteristics while still being closely shaped in detail to the physique and proportions of a specific person. This basic principle of customization allowed a constant stream of incremental modifications to be introduced, which, if demonstrated by experience to be advantageous, could be integrated back into the mainstream of tradition.

The emergence of agricultural societies living a fixed pattern of life was also capable of supporting concentrations of populations, allowing a greater degree of specialization in crafts. In many cultures, monasteries were founded that not only emphasized meditation and prayer, but also had more practical members who had considerable freedom to experiment and were often at the forefront of technological innovation.

More widespread were concentrations of population in urban

communities, where more specialized, highly skilled craftsmen were attracted by the demand for luxuries created by accumulations of wealth. A frequent consequence was the emergence of associations of skilled craftsmen, in guilds and similar organizations, which, for example, already existed in Indian cities around 600 BC. Social and economic stability in an uncertain world was generally the main aim of guilds, whatever their variations across cultures. A widespread function was the maintenance of standards of work and conduct, and, in the levels of control some of them exerted, they prefigured the characteristics of many modern professional associations and represented an early form of licensing designers.

Guilds could often grow in status and wealth to exert enormous influence over the communities in which they were located. During the Renaissance, for example, Augsburg in southern Germany was famous for the exquisite skills of the gold- and silversmiths who were a major force in city life, with one of their number, David Zorer, becoming mayor in the early 1600s.

Ultimately, however, the influence and control of the guilds were undermined from several directions. Where trade between distant centres began to open up, it was entrepreneurial middlemen, taking enormous risks in pursuit of equally enormous profits, who began to dominate production. Industries based on handwork, often using surplus labour in rural areas, undercut

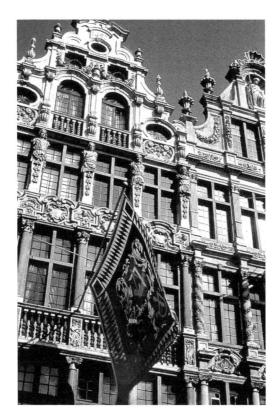

3. Craft, wealth, and status: Guild houses, Grand Palace, Brussels

guild standards and placed control of forms in the hands of entre-
preneurs. In China, the ceramic kilns of Jingdezhen produced
huge quantities of porcelain for export to India, Persia, and
Arabia, and, from the sixteenth century onwards, to Europe.
With distances opening up between maker and market, concepts
had to be represented before being produced. Drawings and
models sent to China from Europe specified forms and decora-
tions to be shipped for particular markets or customers. With the
diffusion of the printing press in late-fifteenth-century Europe,
the circulation of drawings and prints allowed concepts of form
to have wide currency. Individual designers published folios of
drawings for forms and decoration that enabled practitioners to
break with guild control of what could be produced and adapt a
wide repertory of images for product concepts.

Efforts by governments to control and use design for its own
purposes also reduced the power of guilds. In the early seven-
teenth century, the French monarchy used privileged status and
luxurious facilities to attract the finest craftsmen to Paris in order
to establish international dominance in the production and trade
of luxury goods. Laws were introduced to promote exports and
restrict imports. Craftsmen became highly privileged and often
very wealthy in catering for the aristocratic market, and in the
process were freed by monarchs from guild restrictions.

The most sweeping changes, however, came with the onset of

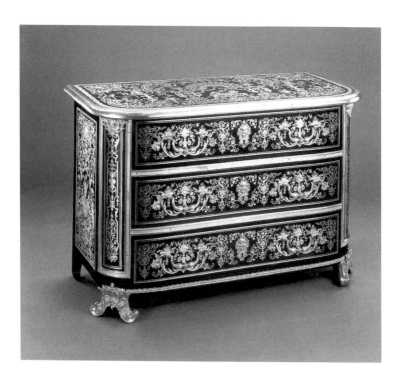

4. Elegance as display: commode attributed to André Charles Boulle,
Paris, c.1710

industrialization in the mid-eighteenth century. The sheer scale of products generated by mechanized processes created a dilemma for producers. Craftsmen were generally unable or unwilling to adapt to the demands of industry. In addition, new sources of form had to be found to entice potential purchasers in the markets that were opening, especially for middle-class customers who represented the new wealth of the age. With competition becoming fiercer as more producers with greater capacity entered markets, and with varying tastes in fashion being necessary to pique the taste of customers, a flow of new ideas was required. Academically trained artists, as the only people trained in drawing, were increasingly commissioned by manufacturers to generate concepts of form and decoration in prevailing taste. The English painter, John Flaxman, worked on several such projects for Josiah Wedgwood's ceramic manufactory.

However, artists had little or no idea of how aesthetic concepts could be converted into products, and new circumstances, as ever, demanded the evolution of new skills. On one level, manufacturing required a completely new breed of engineering designers, who took the craft knowledge of clock- and instrument-making and rapidly extended it to solve technical problems involved in building machines to ensure their basic functionality—building steam-engine cylinders to finer tolerances, for example, yielding greater pressure and power.

Where matters of form were concerned, two new groups emerged as influential. The first functioned on the basis of constantly seeking out new concepts that would be acceptable in markets, who were later to become known as style consultants. The second was a new generation of draughtsmen who became the design workhorses of the first industrial age. Working in factories to directions from style consultants, or from entrepreneurs or engineers, or using artists' drawings or pattern books, draughtsmen increasingly provided the necessary drawing skills for production specifications. Often, they were responsible for generating concepts of forms, based predominantly on copying historical styles or the products of successful competitors.

This specialization of function was a further stage in the separation between how product concepts or plans were generated and their actual production. Creating forms without understanding the context of manufacture, however, increasingly resulted in the separation of decorative concerns from function in many household wares, which led to a deep reaction against what many saw as the debasement of art, taste, and creativity by the excesses of industry. In Britain, the cradle of the Industrial Revolution, figures such as John Ruskin and William Morris established a critique of industrial society that had a profound effect in many countries. Their influence culminated in late-nineteenth-century

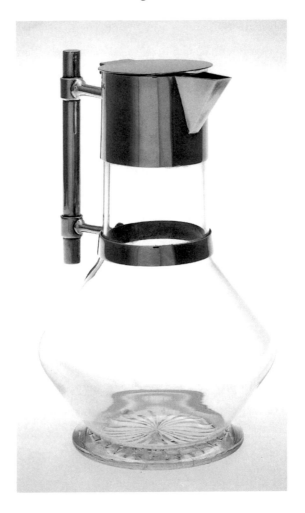

5. Functional simplicity: lidded jug by Christopher Dresser, Sheffield, 1885

Britain, with the establishment of the Arts and Crafts Movement, which promulgated the role of the craftsman-designer as a means of reviving a lost unity of design practice and social standards. The outbreak of the First World War in 1914, however, was such a bitter reminder of the savage power unleashed by modern industry that nostalgic images of a romanticized medieval idyll appeared increasingly indulgent.

Nevertheless, a belief in asserting the power of art over industry continued—a concept that many idealistic artists hoped to realize in the aftermath of the Russian Revolution of 1917, using art through the medium of industry, as a means of transforming Soviet society. The idea also had a powerful role in the doctrines of the Bauhaus, a school founded in post-First World War Germany to address the problems of how society could and should be changed by harnessing mechanical production to spread the power of art throughout all levels of society. As an ideal, it resonated in the consciousness of generations of twentieth-century designers educated in the tenets of the Bauhaus, but the captains of industry were not ready to abandon their authority. The ideal of the artist-designer remains a significant element of modern design approaches, with virtuoso designers such as Michael Graves or Philippe Starck attracting wide attention. However, the ideal of the artist-designer as change-master of modern society has been little realized in practice.

The Historical Evolution of Design

If Europe stimulated a profound body of design theory that stressed the role of art and craft, in the United States, a new scale of industrial technology and organization evolved by the 1920s and profoundly changed design practices. Through mass production based on huge capital investments, giant businesses generated a wave of innovative products that fundamentally changed every aspect of life and culture in America, with reverberations across the globe. To stimulate markets, products needed to be changed constantly, with mass advertising campaigns exhorting consumers to buy with abandon.

A key example is the automobile, which was first developed in Europe as a custom-built plaything for the wealthy, but which with Henry Ford's Model T, first produced in 1907, became accessible to the masses at ever-decreasing cost. Ford, following the logic of mass production, believed his single model was appropriate to all needs. All that was necessary was to produce it more cheaply in ever-greater quantities. In contrast, Alfred P. Sloan, who became President of General Motors, believed new production methods must adapt to different market levels. In 1924 he introduced a policy to reconcile mass manufacture of automobiles with variety in product. By using basic components across several lines, it was possible to give products a different surface appearance to appeal to different market segments. The outcome was the emergence of designers as stylists, specialists in

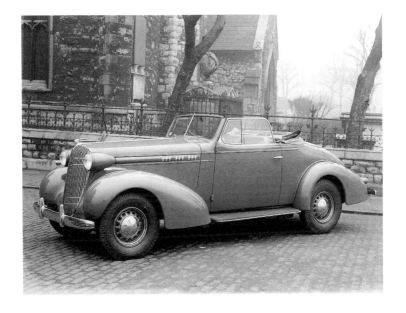

6. Styling becomes mainstream: 1936 Oldsmobile convertible

generating visual forms that above all had to be visibly differenti-
ated from those of competitors.

Some leading designers, however, such as Henry Dreyfuss,
began to evolve a concept of their role encompassing a vision of
social improvement by working in concert with industry. After
the Second World War, designers extended their expertise beyond
concerns with form and began to address problems of more fun-
damental importance to clients' businesses. Donald Deskey, who
came from a background as furniture designer to head a large
New York-based consultancy specializing in branding and packag-
ing, and even an arch-stylist such as Raymond Loewy, argued that
declining American manufacturing quality disillusioned pur-
chasers who, after being attracted by external style, found prod-
ucts unsatisfactory in use. They expressed concern about the
decline of design awareness in American firms that preferred
echoing competitors' products. As an alternative, they advocated
design as a high-level strategic planning activity vital to the com-
petitive future of corporations.

Awareness of change was generated by the American market
becoming a competitive arena for products from around the
world from the 1960s onwards. Large segments of American
industry were subsequently decimated by imports from countries
like Japan and Germany, where greater attention to production
quality and a more holistic approach to design were the norm.

Yet these design approaches, so successful for a time, are also being superseded. Change is evident on many levels. By the 1980s, there began a sharp turn away from the geometrical simplicities of modernism, in a trend generally grouped under the title of postmodernism. This essentially and accurately describes what it is not, rather than what it is, since its main characteristic is an eclectic plethora of frequently arbitrary forms bearing no relation to utility. Much of this is justified by the concept of product semantics, drawing heavily on linguistic theory of signs and meanings. In other words, the meaning of a design is asserted to be more important than any practical purpose, although, since meaning bears little relation to any values, other than the personal inclinations of designers, confusion can ensue.

Another important trend is the effect of new technologies, such as information technology and flexible manufacturing, opening up possibilities of customized products designed in detail for small niche markets. In response, some designers are pioneering new approaches, evolving methodologies that base products on user behaviour, linking hardware and software, and working as strategic planners in the design of complex systems. Interactive design for electronic media is also confronting new problems of enabling users to navigate large and complex bodies of information. Such work is vital in interpreting new technology for potential users.

The Historical Evolution of Design

These changes are part of a repetitive historical pattern. As described earlier, the evolution of a new stage in design does not entirely replace what has gone before, but, instead, is layered over the old. This has been a recurrent pattern throughout the history of design. It not only helps explain why there is such a diversity of concepts and practices about what constitutes design in contemporary society, but also raises a question about the extent to which similar changes will confront us in the future. Exactly what will transpire is uncertain, but the signs are unmistakable—new technologies, new markets, new forms of business organization are fundamentally altering our world, and, without doubt, new design ideas and practices will be required to meet new circumstances. The greatest degree of uncertainty, however, revolves around the question: whose interests will they serve?

3 Utility and
Significance

Although design in all its manifestations profoundly influences life on many levels, it does so in diverse ways. Again, it is necessary to find some bedrock of basic explanation in order to create a sense of order from the apparent confusion. A useful tool to this end is a distinction between utility and significance, which is an attempt to clarify the enormous confusion in discussion of design surrounding the term 'function'.

In 1896, in an essay entitled 'Tall Office Building Artistically Considered', the American architect Louis Sullivan wrote: 'It is the pervading law of all things organic, and inorganic, of all things physical and metaphysical, of all things human and all things super-human, of all true manifestations of the head, of the heart, of the soul, that life is recognisable in its expression, that form ever follows function. This is the law.'

These ideas were heavily conditioned by Darwin's theory of evolution with its emphasis on the survival of the fittest. By the late nineteenth century, ideas that the forms of fish or birds had evolved in response to their elements and that animals and plants were closely adapted to their environment were commonplace. In that context, it could be argued, form must indeed follow function, to the extent that the stripes of a zebra or the brilliant

plumage of a parrot have a distinct purpose in the immutable laws of survival. Similarly, Sullivan's concept of function encompassed the use of decoration as an integral element in design.

Sullivan's concept became encapsulated in the dictum 'Form follows function', and became part of the vocabulary of design, although it underwent something of a transformation in the process. Function in design became widely interpreted in terms of practical utility, with the conclusion that how something is made and its intended use should inevitably be expressed in the form. This omitted the role of decoration and how patterns of meaning can be expressed through or attached to forms. In this respect, it is possible to speak of an alternative dictum: 'Form follows fiction'. In other words, in contrast to the world of nature, human life is frequently inspired and motivated by dreams and aspirations rather than just practicality.

As a consequence, the concept of function has been one of the most hotly disputed terms in design. In the early twentieth century, a broad body of ideas, generally grouped under the umbrella term 'functionalism', articulated design concepts that rejected the florid decoration so typical of the nineteenth century. This could mean several things. For some designers, such as Peter Behrens, who was active in Germany in the early years of the twentieth century, classical architecture and design were a source of inspiration. Stripped of decoration, these could yield forms

that were clean and geometrical, qualities considered desirable in contrast to the heady repertoire of styles typical of the nineteenth century that had been adopted indiscriminately from every canon and culture of history. In like manner, traditional forms could similarly be simplified and refined, as in the work of W. R. Lethaby and Gordon Russell, contemporaries of Behrens, and heirs to the English Arts and Crafts tradition. Both tendencies could simultaneously claim to be contemporary while still retaining continuity through references to the past.

Another more radical tendency that totally rejected the past was articulated after the First World War in Europe. It was primarily associated with such figures as Theo van Doesburg, a Dutch theorist and leading member of the De Stijl group, Walter Gropius, the head of the Bauhaus school in Germany, and Le Corbusier in France. They evolved a repertoire of abstract geometric forms that in theory claimed to be the most suitable for the processes of standardized industrial production. Mass-manufacturing techniques, however, were equally capable of turning out complex, decorated forms, and indeed, in production terms, decoration could be advantageous. In the manufacture of plastic casings for radios in the 1930s, for example, heavy presses were used that made it difficult to produce a simple box-like shape. The problem was that, in the pressing, 'flow-lines' could appear as a consequence of the intense pressure applied, which marred large,

plain surfaces. It was, therefore, better to use some means of breaking up large planes, by, for example, introducing steps into surfaces, or treatments such as stippling or hatching. The claim for clean, geometric form was in fact more significant as an ideology of the role of design in industrial society, rather than reflecting any innate characteristics of production methods. Instead of geometric form being the most suitable in practical terms, it was instead a powerful metaphor of what form in a mechanized age should ideally be. In this it was only one of several concepts that emerged—similar claims could be made with equal validity for the concept of streamlining, with its organic tear-drop curves and speed lines.

In place of dogmatic assertions that limit consideration of what form is considered permissible, a more inclusive definition of function is needed, which can be opened up by breaking the concept of function into a twofold division: the key concepts of utility and significance.

Utility can be defined as the quality of appropriateness in use. This means it is concerned with how things work, of the degree to which designs serve practical purposes and provide affordances or capabilities (and the consequences when they do not). A simple example is a professional kitchen knife used to prepare food: its primary utility value is as a cutting tool. In order for it to work effectively, the blade needs to possess material qualities enabling

a sharp edge to be maintained and for it to remain stable in use. (A blade that is too thin will wobble when pressure is applied, which not only is inefficient but can be highly dangerous.) The processes of use also require that the knife handle fits comfortably in the hand, providing a good, firm grip. On this level, utility is concerned primarily with efficiency, derived from technological and material factors. However, in use, such efficiency can also be a source of great pleasure. When all the detailed aspects are well integrated, the best kitchen knives become an extension of the senses, with a satisfying sense of rightness, fitting into the hand almost inevitably and giving a fine degree of balance and control. In such terms, efficiency moves into a different level of response and meaning, and, indeed, it is sometimes very difficult to separate utility and significance precisely, since in practice they can be closely interwoven.

Significance, as a concept in design, explains how forms assume meaning in the ways they are used, or the roles and meaning assigned them, often becoming powerful symbols or icons in patterns of habit and ritual. In contrast to the emphasis on efficiency, significance has more to do with expression and meaning. Two simple examples of wooden toothpicks (and few forms are more basic) can illustrate the distinction between utility and significance, and also the ways in which they frequently overlap.

The first toothpick—or dental stick, as it is marketed—is pro-

duced by a Norwegian company, Jordan, a specialist in dental products. Under two inches long, it has a highly effective wedge form for the task of cleaning both teeth and gums, not only after a meal, but as part of an ongoing oral hygiene programme. This tiny object encapsulates a high degree of utility that is carefully designed in great detail for its intended task.

The second example is a traditional Japanese toothpick. Circular in form and longer by half an inch than the Jordan example, it has only one end sharpened. The other is a bevelled cone, below which are turned incisions around the shaft. The pointed end is clearly concerned with the primary utility of the object, that of removing food caught between teeth, and at first sight the other end might appear to be purely decorative, its form having no readily discernible purpose. An explanation for this form, however, can be found in traditional patterns of dining in Japanese society. This became an expression of sensibility and refinement, with diners kneeling on tatami mats at lacquered tables. The vessels and artefacts used were frequently works of art in their own right, and none more so than the table, which could have exquisite patterns inlaid or painted on its lacquered surface. Laying chopsticks on such fine surfaces while eating was considered indelicate and so chopstick rests (another combination of utility and significance) evolved, enabling chopsticks to be laid down without the part that had been in the mouth coming into contact

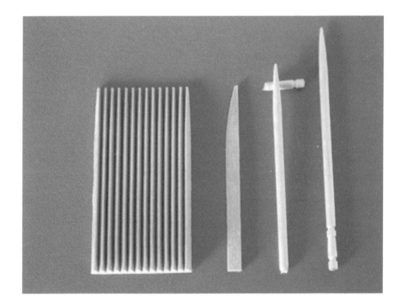

7. Toothpicks

with the table surface. With the toothpicks, however, the solution was built in. The turned incisions of the toothpick enabled one end to be easily broken off, which could then serve as a rest for the pointed end after use. It demonstrates how even the smallest utilitarian objects are capable of simultaneously embodying values.

It is possible to find designs of many kinds defined solely in terms of utility or significance. Many examples of the former are products related to the performance of professional services, tools with highly specific purposes, such as a hand saw or a lathe, or medical equipment, such as an ultrasound machine. Where information has to perform a highly specific task, as in a railway timetable, the layout and type forms should be clean, simple, and directed wholly to imparting essential facts. A primary condition of utilitarian design is that it must effectively execute or support certain tasks. In contrast, a piece of jewellery, a porcelain figurine, or a frame for a family photograph has no such specific purpose—instead their purpose can be described in terms of contemplative pleasure or adornment. Whether their meaning stems from the social taste of a particular fashion or age, or an intensely personal evocation of relationship and meaning, their significance is intrinsic and not dependent upon any specific affordance.

In addition, between the poles where utility and significance

can be clearly identified as the dominant characteristic, there are innumerable products that unite efficiency and expression in an astonishing range of combinations. A lighting fixture can be on one level a utilitarian means of illumination, but at the same time expressive in sculptural form of a highly individualistic, even idiosyncratic, nature. Tableware, cutlery, and glassware serve specific purposes while dining, but again can be manifested in a huge variety of forms, often with complex decorative patterns. Perhaps the classic example of our age is the automobile, which, besides having the very utilitarian task of carrying people and luggage from place to place, has from its early years been an extension of ego and personal lifestyle. Rolls-Royce automobiles, for example, are not only superb examples of technical craftsmanship, but are a symbol of achievement in societies around the globe.

The significance of objects, the precise values imputed to them, however, will often vary considerably between different cultures. In the example of the Japanese toothpick given above, it is important to acknowledge the particular associations with sophisticated courtesy as an expression of Japanese culture. This raises important questions of how cultures evolve patterns of behaviour that become codified as rules or norms, with different cultures expressing values in their own specific way.

Meaning is not necessarily permanently fixed, however, since the significance of products can vary over time and space. A clas-

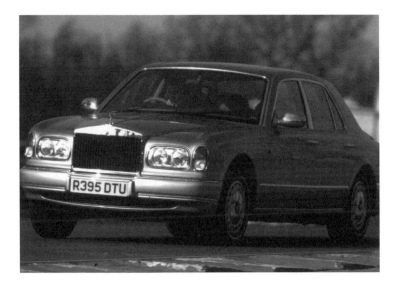

8. The symbol of achievement: Rolls-Royce Park Ward 2000

sic example was the Volkswagen Beetle, developed in 1930s Germany on the direct orders of Adolf Hitler, himself a motoring enthusiast. With production of the first prototypes in 1937, by the 'Strength through Joy' section of the German Labour Front, the official workers' organization, it was promoted as an icon of the achievements of the Nazi Party. When production recommenced on a large scale after the Second World War, the VW was successfully exported to the United States in the 1950s and became a cult object. The design was virtually identical across this period of time, but the significance of the product underwent a remarkable transformation: from an icon of fascism in the 1930s—the 'Strength through Joy car'—to the loveable 'Bug' and hero of Walt Disney's Herbie films in 1960s America. The transformation went further with the redesigned Beetle that appeared in 1997, which also rapidly acquired cult status in the United States.

Basically, concepts of culture can be divided into two broad categories: first, the idea of culture as cultivation, resulting in the acquisition of ideas or faculties expressed in certain styles or behaviour believed to have particular value. A certain hierarchy is involved, in that a concert of classical music is considered more significant than a rock concert, or a piece of sculpture more than a work of industrial design. To some extent, design has begun to be drawn into this sphere, as evident by the number of art museums that have developed collections and held major exhibitions of

design. Incorporating design into concepts of exclusivity, often under the term 'decorative art', however, has often more to do with museums' search for contemporary justification than with understanding the role of design in modern life.

The second major concept of culture, and the one underlying this book, is based on a more generalized view of culture as the shared values of a community. In this sense, culture is the distinctive way of life of social groups—the learned behaviour patterns expressed through such aspects, as values, communications, organizations, and artefacts. It encompasses the fabric of everyday life and how it is lived in all its aspects and allows consideration of a broader range of design and its role in people's lives. It has the virtue of including more elite definitions, but as part of a broader range of discussion.

The influence of cultural values, as manifested in interpretations and meanings of designed objects, is felt at many levels. In the past, and continuing to some extent, very different objects for broadly similar functions evolved around the world, resulting in great diversity. If one examines, for example, how food is prepared, in China it is still widely cooked in a wok, compared to a range of specialized pans used in European kitchens. The food prepared in the former is eaten with chopsticks, the latter with an array of often very specialized cutlery. In these and innumerable other ways, the specific forms are the expressions of partic-

47

ular cultural contexts, habits, and values that have evolved in their particularity over time.

Two main levels of difficulty occur in confronting the specific characteristics of time and place. The first arises from the need to conform to existing cultural patterns, to integrate or assimilate in ways that cause no disruption or offence. The second involves navigating unavoidable changes in such patterns, which becomes infinitely more complex.

Problems seem to be fewer and of lesser intensity if products are simple and utilitarian, which minimizes the possibility of cultural conflict. World markets for a vast array of luxury products, such as Hermes leather goods, that are inherently simple even though expensive can be treated in an undifferentiated manner.

The consequences of not acknowledging the power of cultural diversity can be surprising. In the early 1980s a Harvard marketing expert, Theodor Levitt, achieved considerable prominence with his ideas on globalization, among which he argued that differences were lessening and standard products across the globe were the marketing tools of the future. It was perhaps coincidence, but, at the same time, the management of the appliance manufacturer Electrolux became convinced that Europe should become a single market for refrigerator/freezer units, like the USA, where a few large manufacturers make a limited range of designs. A policy introduced in 1983 to push towards this end

proved costly, however, as the divergent cultures of Europe intransigently failed to follow the American pattern. In Northern Europe, for example, people shop weekly and need equal freezer and refrigerator space. Southern Europeans still tend to shop daily in small local markets and need smaller units. The British eat more frozen vegetables than elsewhere in the world and need 60 per cent freezer space. Some want the freezer on top, some on the bottom. Electrolux attempted to streamline operations but seven years later the company still produced 120 basic designs with 1,500 variants and had found it necessary to launch new refrigerators designed to appeal to specific market niches.

Packaging and visual imagery can also be a minefield. The former CEO of Coca-Cola, Roberto Goizueta, recounted that, when his company entered the Chinese market, it was discovered that the phonetic pronunciation of the company name translated as 'Bite the wax tadpole'. The problem was identified before major production began and the ideograms on packaging were sensibly adapted to mean 'Tasty and evoking happiness'.

In another example from East Asia, one of the stranger illustrations of the cultural perils of globalization was a leading brand of toothpaste, marketed for decades under the brand name of 'Darkie'. Its packaging had a cartoon-like illustration of a stereotyped, black-face minstrel with top hat, and teeth gleaming pearly white. In its market of origin nobody apparently found this trou-

blesome, but Colgate-Palmolive's purchase of the Hong Kong manufacturer of this product in 1989 brought unexpected problems at home. A rumour rapidly spread in the USA that the company was selling a racist product and banner-carrying pickets appeared outside its New York headquarters. To appease American critics without destroying a well-known brand in Asia, Colgate-Palmolive sought to redefine the brand name as 'Darlie', with a visual redesign to match. The packaging image was modified to show an elegant man about town of indeterminate ethnic origin, but still in white tie and top hat and with gleaming teeth.

Globalization, however, should not be considered only in terms of problems of adaptation or conformity. Theodor Levitt was indeed partly right in pointing out ways in which trends in technology and communications were linking the globe together and in some respects radically altering notions of culture. The influence of globalization means that culture does not necessarily remain dependent on a specific environment, with everyone adhering to the same broad, homogeneous set of values and beliefs. It raises the possibility of having a culture different from those around us. Cultural multiplicity rather than homogeneity and an emphasis on cultural creation rather than cultural inheritance would appear on many levels to be patterns for the future. Any such transition, however, will not be simple or easy.

The role of design substantially contributes to such develop-

ments by creating change in values across national or ethnic boundaries. This can be on the level of products, such as motor cycles and television sets, but probably more powerfully from the constant imagery associated with global television broadcasts and advertising, as with CNN, the configuration of an online interactive site, such as Amazon.com, or the corporate identity of McDonald's or Coca-Cola. Their ubiquity and widespread appeal can create substantial friction and have attracted attacks from divergent sources, among them French nationalism, Russian fascism, and Hindu and Islamic fundamentalism. These all differ in origins and rationale, but have in common a resentment of new patterns of cosmopolitanism presented by the imagery of global design, in the name of protecting cultural identity. It would be a mistake, however, to identify all reactions to globalization with those of extreme groups. Many people are genuinely concerned about the loss of local control and identity to forces that frequently appear remote and not answerable for their actions. The utility of being able to watch new broadcasts from the other side of the world may not compensate for children being profoundly influenced by imagery and behaviour that can appear alien and threatening. Even on a more mundane level, it is easy to give offence. A major advertising campaign in Japan for an American brand of soap had a man entering the bathroom while his wife was in the bathtub, behaviour that might be thought to express sexu-

al attraction in the USA, but which was considered ill-mannered and unacceptable in Japan.

These reactions cannot be dismissed as the inevitable consequences of change. The role and power of technology are indeed a problem when the ability to communicate simultaneously around the world, a marvellous development by any standards, is regarded as a threat. There are also far too many products and services being placed on world markets in which little or no concern is evident about whether they are comprehensible or usable. An assumption of uniformity in global designs as a basis for solutions can indeed create new problems, when a little forethought could have ensured appropriate adaptation to local conditions.

Obviously, the ability of human beings to create meaningful form spans a very broad spectrum of possibilities. At their most profound level, forms can embody metaphysical significance, going beyond the boundaries of tangible form to become symbols of belief and faith, expressing the deepest beliefs and aspirations of humankind. Nothing in the specific form of totems from Pacific Island tribes or the North American plains, or of statues of Buddha or Shiva, or the Christian cross can even hint at the complexity of the beliefs and values they represent. Yet the significance of such symbols becomes regarded as an objective social fact, understood by all who share the beliefs they symbolize. At the same time, it is also possible for people to invest objects with

intense personal meaning that need not conflict with broader patterns of belief in a culture.

In 1981, two Chicago sociologists, Mihaly Csikszentmihalyi and Eugene Rochberg-Halton, published the conclusions of a research project on the role of objects in people's lives, entitled *The Meaning of Things*. They wrote of

the enormous flexibility with which people can attach meanings to objects, and therefore derive meanings from them. Almost anything can be made to represent a set of meanings. It is not as if the physical characteristics of an object dictated the kind of significations it can convey, although these characteristics often lend themselves certain meanings in preference to others; nor do the symbolic conventions of the culture absolutely decree what meaning can or cannot be obtained from interaction with a particular object. At least potentially, each person can discover and cultivate a network of meanings out of the experiences of his or her own life.

The capacity of people to invest objects with meaning, to become imaginatively involved in creating from an object or communication a sense of significance that can reach far beyond what designers or manufacturers envisage, has not been given much credence in the age of mass production and advertising. All too often the emphasis is on imposing patterns of meaning and conformity from the standpoint of producers. However, this human capacity to invest psychic energy in objects is immensely power-

ful, with significant ramifications for the study and appreciation of design. In an important sense, it can be argued that the outcomes of design processes, the end result, should not be the central concern of the study and understanding of design, but rather the end result should be considered in terms of an interplay between designers' intentions and users' needs and perceptions. It is at the interface of the two that meaning and significance in design are created. For this reason, subsequent chapters exploring the outcomes of design in more detail will not be organized according to the categories widely used to define professional design practice, such as graphic or industrial design (although it will be necessary to discuss such terms). Instead, the chapters are grouped in terms of generic concepts: objects, communications, environments, systems, and identities, in which the concept of users', as well as designers', response and involvement can be further explored.

4 Objects

The term 'objects' is used to describe a huge spectrum of three-dimensional artefacts encountered in everyday activities in such contexts as the home, public spaces, work, schools, places of entertainment, and transport systems. They range from simple single-purpose items, such as a saltshaker, to complex mechanisms, such as a high-speed train. Some are an expression of human fantasy, others of high technology.

Objects are a crucial expression of ideas of how we could or should live, put into tangible form. As such, they communicate with an immediacy and directness that is not just visual, but can involve other senses. Our experience of an automobile is not solely through how it looks, but also through the feel of seats and controls, the sound of the engine, the scent of upholstery, how it rides upon the road. The orchestration of sensual effects on several levels can have a powerful cumulative impact. Such diversity in how objects are conceived, designed, perceived, and used also provides multiple perspectives from which they can be understood and interpreted.

The terminology of the professional practices involved is an additional complication. 'Product designer' and 'industrial designer' are in reality virtually interchangeable and both claim a

role in thinking about product form in terms of the relationship between technology and users. 'Stylist' is more limited, a term describing a preoccupation with aesthetic differentiation of product form, usually under the control of marketers. 'Industrial artist' is an older term that is still occasionally used, emphasizing again a focus on form in aesthetic terms. Many architects can also work as designers, employing a variety of approaches. For particularly complex objects, perhaps with highly specific performance requirements, the form may be determined by engineering designers on the basis of technological criteria. An additional complication is that complex objects can require multidisciplinary teams involving many disciplines working in close cooperation.

Within the framework set out at the end of the previous chapter on the interplay between designers' and users' concerns, it is clear that there are some designers who, on balance, are more preoccupied with their own ideas, rather than with those of their users. Reinforcing such approaches are theoretical ideas grouped under the heading of postmodernism, which emerged in the 1980s, emphasizing the semantic value of design, rather than its utilitarian qualities. In other words, it is the meaning of a product, rather than the uses to which it is put, that is the primary criterion in its conception and use. It is not users, however, who are the focus of these concepts, but designers, which opens the door

to products taking on arbitrary forms that may have little or nothing to do with use, but are justified by their 'meaning'. An example is the Italian company Alessi, which, in addition to a long-established range of household items of great simplicity, has in recent years offers a stream of products epitomizing this tendency. Perhaps the most well known is the lemon squeezer designed by Philippe Starck, under the name 'Juicy Salif'. Starck has a great talent for designing striking, unusual forms, as is obvious in this object. It is, however, signally deficient in the practical purpose it purports to fulfil and is instead intended to function as a 'household icon'. To have this item of fashionable taste adorn a kitchen, however, costs some twenty times that of a simple and infinitely more efficient squeezer—in fact, the term 'squeezer' should perhaps be more appropriately applied to profit leverage, rather than functionality for users.

This particular approach to design has been avidly adopted by innumerable companies looking to inject added value into products on which profits margins are low. As a result, postmodernist ideas in design have been widely appropriated for commercial purposes in order to convert efficient, inexpensive, and accessible products into new manifestations that are useless, expensive, and exclusive. The emphasis on meaning, moreover, unlocks a vista of unlimited possibilities for the elaboration of ever-new forms requiring little or no relationship to purpose, enabling

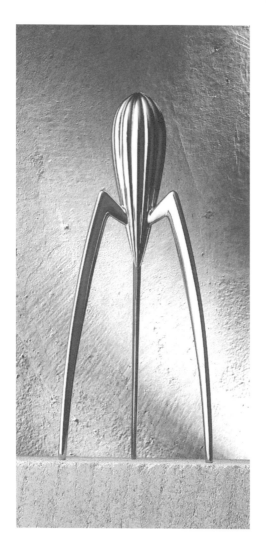

9. Pricey inefficiency as high style: 'Juicy Salif' by Philippe Starck, for Alessi

products to be drawn into cycles of fashionable change for the primary benefit of manufacturers.

Fashion, basically, depends upon many people's concepts of suitability being heavily influenced by what they see others doing and purchasing. As such, it is an innate characteristic of human nature. From this perspective, goods are indicators of social and cultural status. As disposable income has been more widely available for larger proportions of populations in advanced industrial countries, the potential for conspicuous consumption and so the demand for distinctive products have undoubtedly expanded and been subject to intense manipulation. Among the responses to this phenomenon has been the emergence of 'designer-brands', which have proved to be powerful devices, particularly in the more expensive sectors of the product spectrum.

An example is Ferdinand Porsche, grandson of the designer of the original Volkswagen 'Beetle', who began work in the family car company and set up his own design studio in 1972. His design activity includes work on large-scale products, such as trains for the Bangkok Mass Transit System, street trams for Vienna, and speedboats, which have a strong utilitarian element. He is best known, however, for small, exclusive personal items, such as tobacco pipes and sunglasses, made in cooperation with leading manufacturers. Even though these latter firms have a high reputation in their own right, such as Faber-Castell or Siemens, prod-

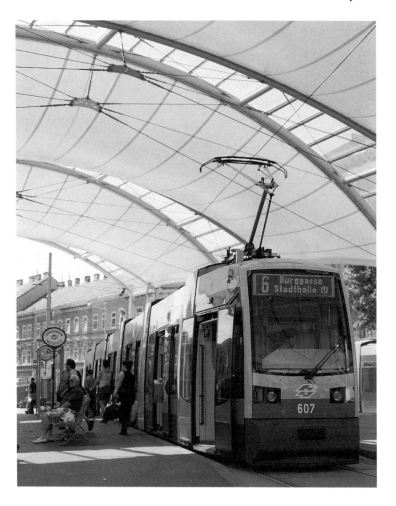

10. Access and convenience for all: Vienna streetcar designed by Porsche

ucts are marketed as a Porsche Design, which has become a fashionable identifier in its own right for luxury products.

It would be misleading to imply that all such 'designer-centred' approaches are focused solely on differentiating form as a means of adding value. Some individuals evolve insights into people's lives, with the results that they design radically new solutions to problems that might seem obvious once manifested in tangible form—in other words, giving users what they never knew they wanted—one of the most innovative roles design can play.

One of the greatest influences on form in the modern world, in this sense, has been Giorgetto Giugiaro. He also started out as an automobile stylist, working for FIAT, Carrozzeria Bertone, and Ghia, before founding Italdesign with two colleagues in 1968. No one has more influenced the direction of automobile styling around the world than Giugiaro. His concept of the Volkswagen Golf of 1974 set the pattern for subsequent generations of small, hatchback cars and a 1978 design for Lancia was the first minivan. Clean contours and lines, without superfluous decoration, typify his work. Italdesign worked on some industrial design projects, but in 1981 an offshoot, Guigiaro Design, was established to concentrate specifically on a broader range of products. These have included cameras, watches, express trains (even these have his signature), subway trains, motor scooters, housewares, aircraft

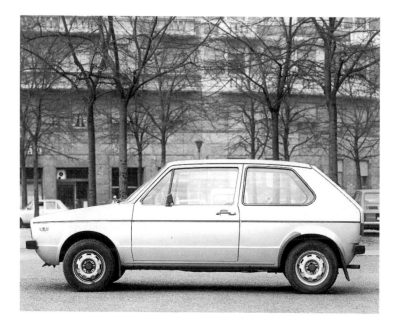

11. The hatchback sets a new pattern: VW Golf by Giorgetto Giugiaro,
1974

interiors, and street furniture. More recently he, too, has intro-
duced a range of personal and fashion goods.

For some designers, retaining a degree of control over their
work in order to guarantee its integrity is an essential dimension
of practice. Being able to do so while being highly successful com-
mercially demands creative skills and business acumen of a high
order. Stephen Peart, whose company, Vent Design, is based in
California, has such a reputation for innovative concepts and high-
quality designs that marketing his services is unnecessary and a
string of major companies have beaten a path to his door. He has
rejected growth in order to keep overheads low and maintain the
possibility of choice in the clients whose commissions he accepts.
The integrity of his work is maintained by insisting on agreements
stipulating that a contract is void if his design concepts are
changed without his consent.

There are also companies where the influence of individuals
can be decisive, particularly in establishing a philosophy about the
role objects should play in people's lives. An example is in the
field of domestic electrical appliances, such as toasters, kitchen
mixers, and hair dryers. These are in fact used for only a few min-
utes in any day and the question of what role the forms should
play in the long intervals when they are not used is pertinent.

The German designer Dieter Rams used the metaphor of a
good English butler: products should provide quiet, efficient

service when required and otherwise fade unobtrusively into the background. (A former butler from Buckingham Palace advising the actor Anthony Hopkins on his role in the film *Remains of the Day* commented: 'When you are in a room it should be even more empty.') Rams's designs for Braun over a forty-year period through to the mid-1990s used simple, geometric forms and basic non-colours, predominantly white, with black and grey used for details, and primary colours applied only for small and highly specific purposes, such as on/off switches. The consistent aesthetic cumulatively established by Braun was one of most formative influences on houseware design in the late twentieth century and established instant recognition for the company that many have sought to copy but few have equalled.

In contrast, similar appliances produced by the Dutch company Philips, under the design direction of Stefano Marzano, have tended to be more assertive visual statements, with a range of organic forms and bright colours, implying that such objects serve a more prominent visual role in the home when not in use.

Highly individual and innovative approaches to form can be particularly successful when allied to genuine improvements in product performance. Apple's iMac computer series designed by Jonathan Ive and introduced in 1998 caused a sensation with its incorporation of transparent plastics, in what were often referred to as 'toothpaste colours', on casings and accessories. Ive's inno-

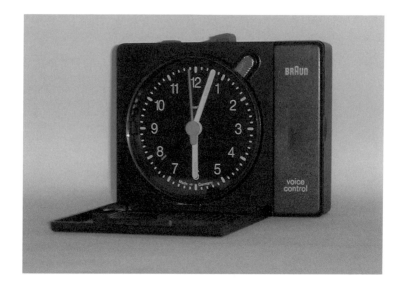

12. The language of simplicity: Braun travelling clock, Type AB 312,
by Dieter Rams and Dietrich Lubs

vative concept of what computer form could be cleverly signalled a new emphasis on accessibility and connectivity in the iMac series, targeting sections of the population who had not previously used computers. It certainly set a huge trend in motion, with the use of such colours so widespread that it became repetitive and meaningless, yet another trend ready to be superseded.

A striving to demonstrate individual personality through designs should not be surprising. Most designers are educated to work as individuals, and design literature contains innumerable references to 'the designer'. Personal flair is without doubt an absolute necessity in some product categories, particularly relatively small objects, with a low degree of technological complexity, such as furniture, lighting, small appliances, and housewares. In larger-scale projects, however, even where a strong personality exercises powerful influence, the fact that substantial numbers of designers are employed in implementing a concept can easily be overlooked. The emphasis on individuality is therefore problematic—rather than actually designing, many successful designer 'personalities' function more as creative managers. A distinction needs to be made between designers working truly alone and those working in a group. In the latter case, management organization and processes can be equally as relevant as designers' creativity.

When a design consultancy grows beyond a certain minimum

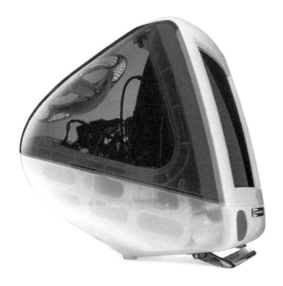

13. Style and connectivity: Apple iMac by Jonathan Ive,

size, the necessary time committed to managerial functions inevitably makes it difficult to maintain personal levels of creativity. Michele de Lucchi has a consultancy with some fifty employees in Milan and corporate customers around the world. Clearly, not all consultancy work can be executed by de Lucchi himself, although his personal control establishes direction and standards. However, to sustain his capacity as a designer, he has also established a small production company, enabling him to continue working at a level of personal exploration and self-expression not possible with the more strictly defined corporate emphasis of mainstream work.

In other areas of design work, however, a group ethos predominates. Many design consultancies are organized as businesses and lack any specific reference to an individual. They often have large numbers of employees located in offices around the world working on a huge range of projects. One of the best known, IDEO, was founded by combining British and American consultancies and by the late 1990s had offices in London, San Francisco, Palo Alto, Chicago, Boston, and Tokyo. Metadesign, after being founded in Berlin, similarly functions on an international level, with affiliates in San Francisco and Zurich. While some consultancies provide a general range of competencies, others can focus on a particular area of work. Design Continuum in Boston emphasizes close cooperation between designers and

engineers with a specialist capability in designing medical equipment. Teamwork is frequently a characteristic of consultancy work and the specific contribution of individuals may be veiled.

Corporate design groups necessarily focus on specific products and processes manufactured by their company, which offers the possibility of going into depth on specific problems and working on several generations of products. Again, they take many forms. An ongoing problem in such groups is the need to maintain specific expertise without getting stale, which means injections of fresh stimuli. Some combine a small in-house group for continuity, with consultants occasionally brought in to add a broader perspective. In others, such as Siemens and Philips, the corporate group is expected to function as in-house consultants, having to bid for the company's work on a competitive basis against outside groups, and being free to do work outside the company. Some corporate giants, particularly Japanese companies, have very large in-house groups, 400 designers being not unusual, although many of these may work only on a detailed level, designing minor variations of existing products in an effort to satisfy a broad range of tastes.

If references to 'the designer' indicate a bias towards individuality in much design thinking and commentary, another widespread singular reference—the phrase 'the design process'

—suggests a unity that is non-existent in practice. There are, in fact, many design processes, adaptable to the immense variety of products and contexts in which designers work.

At one end of the spectrum are highly subjective processes based on individual insight and experience. These can be difficult to explain and quantify. Particularly in corporate contexts dominated by the numerical methodologies of finance and marketing, with their apparent ability to demonstrate 'facts', it is easy for such approaches to be underestimated. There is a welcome recognition in economic and business theory, however, that in many disciplines the kind of knowledge based on experience and insight—tacit knowledge—can be a vital repository of enormous potential. Much design knowledge is indeed of this kind, although this does not mean an ability to design should be limited to the tacit dimension. There is a vital need to extend alternative forms of knowledge in design that can be structured and communicated—in other words, coded knowledge.

Most practical disciplines, such as architecture and engineering, have a body of basic knowledge and theory about what the practice is and does that can serve as a platform, a starting point, for any student or interested layman. The absence of a similar basis in design is one of the greatest problems it faces. Emphasizing tacit knowledge means that many design students are expected to reinvent the wheel, acquiring knowledge in an unstructured man-

ner through learning-by-doing. In effect, more rational methods of enquiry and working are considered irrelevant.

Tacit, subjective approaches may be appropriate for small-scale projects—for example, where the emphasis is on differentiating form. In contrast with large-scale projects involving complex questions of technology and the organization of interactions on many levels, personal intuition is unlikely to be capable of handling all necessary aspects. In such projects, rational, structured methodologies can ensure the full dimensions of projects are understood as a platform for creative solutions on the level of detailed execution. Where, for example, the fit between an object and user is of primary importance, ergonomic analysis based on data about human dimensions can ensure that a form will be appropriate for a desired portion of any given population. The Aeron chair, designed by Don Lawrence and Bill Stumpf for the Herman Miller corporation, is a finely detailed office chair creatively elaborated on the basis of minutely detailed ergonomic data.

Computer-based approaches have also been developed for application to the analysis of very large and complex problems. One such programme, known as Structured Planning, has been developed by Charles Owen at the Institute of Design at the Illinois Institute of Technology in Chicago. With the aid of computers, problems are decomposed into their constituent elements that can be analysed in detail and reconfigured in new creative

14. Form and ergonomics: Aeron chair, by Don Lawrence and Bill Stumpf
for Herman Miller

syntheses. In work for companies such as Steelcase, the world's largest manufacturer of contract office furniture, structured planning has been used to generate new insights and proposals for development in large, complex markets. For Kohler, producer of bathroom fittings, its application has generated a large number of product proposals, of which one to reach the market is a bathtub within a bathtub, enabling the bather to fill the inner bath to the brim for a deep soak.

Market analysis is also a long-established and powerful tool in generating ideas. In the early 1980s, the design group at Canon analysed patterns in copier sales and found the market was dominated by very large, highly expensive machines based on cutting-edge technology. Speculation about whether smaller machines, personal copiers, based on a miniaturization of existing well-proved technology at a relatively low cost, could be feasible led to a hugely successful extension of the market and a dominant position in it for Canon.

On another level, methodologies seeking to understand the problems of users have been adapted from disciplines such as anthropology and sociology. An example is using behavioural observation to gain insights into difficulties that people have in varying contexts, such as working environments, shopping, or learning. Detailed observation over time and space can reveal difficulties that can be addressed by new design solutions.

Although most objects are created with particular uses in mind, however, there are problems in basing interpretations on designers' original intentions. These can be undermined or even reversed in the processes of use by people's infinite capacity pragmatically to adapt objects to purposes other than those originally intended. (Consider for a moment the alternative uses to which a metal paperclip can be put.) A chair can be intended as a seat, but may also be used to stack papers or books, to hang clothes, to keep a door open, to stand on and change a light bulb. VCRs were originally intended by their manufacturers for playing prerecorded tapes, but were soon adapted by users for time-shifting television programmes, recording them on a blank tape so they could be watched at a time convenient to the viewer, rather than the broadcasting company. In general, the additional functions can either complement or enhance the original intention, although this is not always the case. Table knives or scissors can be readily used as injurious weapons, as innumerable police records attest.

Some manufacturers endeavour to use this talent for adaptation as a positive resource. If unsure of what to do with a new technology or product, they frequently launch it on the market in a form encouraging experimentation by users, hoping the huge talent for adaptability will discover feasible applications. After a 3M researcher discovered a new glue that would not stick permanently, the resulting range of Post-It products evolved very large-

ly from observing how people adapted the original plain paper format to a wide range of uses, such as book-markers, fax labels, or shopping reminders. The spectacular evolution of sports shoes has followed a similar trajectory largely derived from observing new and unusual ways of how young people use them on the street.

Another way of involving customers is represented by IKEA, the furniture company founded in Sweden by Ingvar Kamprad in 1951. Now with stores all over the world and a thriving mail-order business, IKEA has redefined production processes by incorporating customers into them. In selling flat-pack components designed for easy transportation, it has to design each item so customers can assemble them easily at home, resulting in large cost savings, part of which are passed on to the customer as lower purchase cost. The success of IKEA has also been based on a consistent design approach, predominantly an updated Swedish Arts and Crafts style, which it projects in all its operations, giving it a local character in global markets. This has caused some problems in the context of use, however, as when it first marketed beds in the USA that were the wrong size for American sheets and covers.

In considering what level of innovation is appropriate and what design approach is best for particular products, the concept of life cycle is important. In the earliest stages after any new product

appears, when uncertainty abounds, formal experiment will be a characteristic, with a variety of possibilities being probed. As the market grows and settles, products take on specific characteristics and become standardized, the emphasis swinging to production quality and cost. In the experimental stage of personal computers in the early 1980s, for example, a variety of possibilities existed. Then the IBM PC format became dominant, with Apple playing a subsidiary role for graphic applications. More recently, the emphasis has been on companies like Dell or Compaq delivering a product in which basic quality and performance are taken for granted, based on a highly efficient, cost-effective production system. In well-established, saturated markets, multiplying features and visual difference of any kind frequently becomes widespread. Conventional telephones, under the impact of increased competition from other systems such as mobile phones, have reached this advanced stage of 'feature creep'. It is supposedly possible to buy telephones with over eighty functions (most impossible to understand) in a superabundance of forms, including bananas, tomatoes, racing cars, sports shoes, and Mickey Mouse.

Sometimes basic product forms manage to resist this proliferation, however, becoming so well established in terms of functionality that it is extremely difficult to change them. An example is the electric iron, for which the basic sole-plate format is so

appropriate for its task that minor variations of the existing form are the only design options.

A major constraint on design is presented by legislation on a variety of matters that might not specifically mention design, but sets tight parameters for performance. In the USA, this includes product liability laws, making manufacturers liable for injuries resulting from a product, and the Americans with Disabilities Act, which stipulates environmental and transportation requirements to provide access for people with disabilities. In Germany, a range of environmental legislation requires products or packaging to be made from materials which can be recycled, with manufacturers responsible for packaging disposal. Failure to incorporate such requirements into product specifications can be costly.

A further challenge for contemporary designers is the need to keep pace with evolving technologies. The replacement of mechanical sources of power and function by electricity during the twentieth century, and, towards its end, the widespread introduction of electronic technology, have fundamentally changed the nature of many objects. Theories about form being a reflection of function have been demolished by the dual effects of miniaturization in printed circuits and astonishing increases in processing power encapsulated in computer chips. Processes are no longer visible, tangible, or even understandable, and the containers for such technology have become either anonymous or subject to

manipulations of form in attempts to create fashion or lifestyle trends.

An example of anonymity is the automated teller machines (ATMs) that have become such a common feature across much of the globe. They exist not as objects in their own right—indeed they are often incorporated into the wall of a building—but as a point of delivery for services that were once carried out by bank tellers. To do this they are a combination of hardware and software. The physical structure needs above all to protect the money contained inside. The key element for users, on the other hand, is the software, the interactive program enabling them to obtain cash. It is, therefore, not the ATM as an object in its own right that is important, but the interface with the computerized system. Their convenience is an enormous improvement on what previously existed, yet they are often cited as evidence of a widespread process of alienation. It is not the technology that is alienating, however, but inadequately thought-through design solutions to new problems.

There are predictions that in the future microchips will revolutionize an even-greater range of objects. It is feasible for a chair to have built-in sensors that respond to sitters, automatically adjusting to their dimensions and desired posture. Similarly, sports shoes that adjust to whether a wearer is standing, walking, or running, on tarmac, grass, sand, or rocks, are entirely con-

ceivable. The forms in which such conveniences are embodied will, however, raise more questions about the relationships between the designers of objects and their users. Are objects to be primarily the plaything of designers' egos, in a manipulative effort to create wants, or are they truly to answer needs in ways responsive to, even created by, users on the levels of both application and meaning?

5 Communications

'Communications' is here used as a shorthand term to cover the vast array of two-dimensional material that plays such an extensive role in modern life. Two-dimensional media forms have multiplied and expanded to a point where we are continuously bombarded with visual imagery. Their influence is pervasive, in both positive and negative senses: they can inform, direct, influence, arouse, confuse, and infuriate. Switch on the television, browse the Internet, walk down a street, read a magazine, or go into a store, and we are confronted with a huge array of signage, advertising, and social advocacy on a variety of scales. Some images will be permanent—a street sign, for example—but, in comparison to objects, a much greater proportion of communications is ephemeral, such as newspapers and advertising materials.

Another important difference between objects and communications should also be noted. Objects can exist as visual forms in their own right and can be used without any other reference. A vase or Lego building blocks for children, for example, do not necessarily require any accompanying text in order for them to be used or understood. They have visual or tactile qualities that communicate directly with great effect. Two-dimensional images, however, are different. As a means of personal expression they

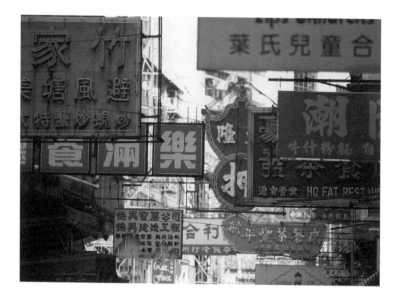

15. Competition made visible: Hong Kong street signs

communicate with great immediacy. They can have a profound effect in stimulating a range of reactions, although this may not be exact or capable of calculation in advance. For practical purposes, however, in forms such as maps or diagrams, imagery in two dimensions generally requires being supplemented by text for it to establish any kind of precision. Attempts to use icons and pictograms effectively to convey meaning have had some success, especially in contexts where people from many countries and speaking many languages are expected to be users. The comprehensive signage system designed by Otl Aicher for the 1972 Munich Olympics is a classic example that has been widely imitated. Nevertheless, in general, an advertisement, or a brochure on how to use a product, or a chart or diagram without any text of any kind will probably be confusing and unclear. In general, therefore, a combination of print and imagery is fundamental in understanding communications.

As with the design of objects, numerous kinds of practice are involved in designing communications, covering an enormous range. Perhaps the most generally used is 'graphic designer', a term that emerged in the 1920s and that characterizes someone whose concern is with two-dimensional imagery. Like much terminology in design, however, it can be confusing, encompassing people who design letterheads for small businesses to those devising a visual identity programme for a major corporation.

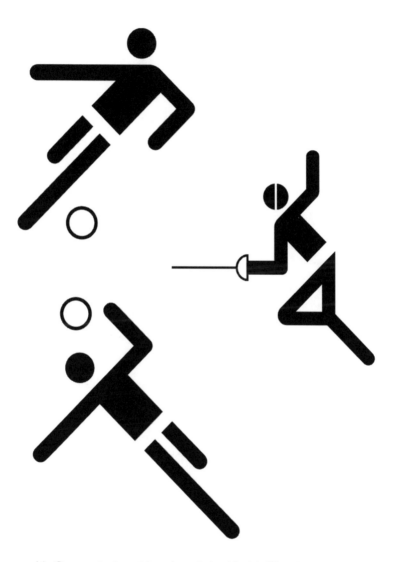

16. Communication without boundaries: Munich Olympic pictogram system, by Otl Aicher 1972

Communications

Whatever the level of application, however, graphic designers employ a common vocabulary of signs, symbols, type, colour, and pattern to create messages and structure information.

Like designers of objects, graphic designers can also work as consultants or as in-house employees for organizations. Some consultants are able to work in a highly personal style, such as the American designer April Greiman, who, after initial training in the USA, studied in Switzerland, one of the fountainheads of modern typography. She is best known as a pioneer of the use of computers in design—'the leading lady of design with a mouse', as she has been termed. Greiman exploits the ability of computers to handle diverse materials, various kinds of images and text, and layers them in striking compositions of great depth and complexity. After many years of running her own business in Los Angeles, in 1999 she became a partner in the international consultancy Pentagram, but, as with all partners in this firm, continues to have total control over her own work.

Graphic consultancies can be giant organizations, perhaps the most notable being Landor Associates, founded in 1941 in San Francisco by the late Walter Landor, who was born in Germany and trained as a designer in England. He believed that understanding consumers' perception of companies and products was at least as important as understanding how products were manufactured, and on that basis, built his consultancy into one of the

world's leading specialists in the design of branding strategies and corporate identity. Sixty years after its foundation, it has over 800 employees working in twenty-five offices spanning the Americas, Europe, and Asia. It has created innumerable brand images for companies that are known the world over. The range includes corporate identity programmes for numerous airlines, such as Alitalia, Delta, Cathay Pacific, Varig of Brazil, and Canadian Airlines. Other identity programmes from a very extensive list include France Telecom, FedEx, BP, Hewlett-Packard, Microsoft, Pepsi-Cola, Kentucky Fried Chicken, and Pizza Hut. Designs for a range of major events also feature in its portfolio, including the symbol for the 1996 Atlanta Olympics, and full identity programmes for the 1998 Olympic Winter Games in Nagano, Japan, and the 2002 Olympic Winter Games in Salt Lake City. The continuity of work and growth by the Landor organization over many years is impressive, especially compared to other large design consultancies that grew rapidly to considerable size, only to crash precipitously.

In-house graphic work for companies, compared to the design of objects, tends to be somewhat less specialized, since the range of materials is likely to be far broader, but a necessary focus will continue to be on what is relevant to the company in question. The spectrum of work and responsibilities is potentially huge. Businesses that routinely generate large quantities of brochures,

instruction leaflets, packaging, and labels need a staff of graphic designers to maintain the flow of such materials. Some in large companies may work more on the level of creative interpretation rather than original concept, within the framework of a corporate identity programme devised by outside consultants. On the other hand, a corporate context does not necessarily restrict designers in this way—publishers of books, magazines, or record covers routinely require designers to create highly original, one-off material.

Government bodies of all kinds also produce huge amounts of forms and documentation. These often demand a major effort by citizens to decipher them and fill out the requisite information, with bureaucratic jargon, tiny print, and inadequate space to fill in answers. An example of how improvement in this field can be dramatic is the Passport Application form in the United Kingdom. Understanding the form's requirements was once a tortuous process, but effective graphic devices now enable it to be easily comprehended and rapidly completed, demonstrating there is no innate reason why designs for governments should be turgid. Indeed, it was the City of New York, in a period when the collapse of the city as a functioning entity was widely predicted, that commissioned Milton Glaser's use of a heart shape in his 'I love New York' device—one of the most imitated graphic forms ever created.

Public, non-commercial bodies of a wide variety also generate extensive design requirements. One of the most influential design programmes in broadcasting organizations is maintained by the Boston Public Television station, WGBH, with a staff of thirty designers. Establishing the station's visual identity requires a large spectrum of means, for both on-screen application and a variety of collateral materials. These include logos, programme introductions and titles, animated sequences, teaching materials, membership information, annual reports, books, and multimedia packages.

Many churches and charitable organizations also depend widely on published materials. The Church of Jesus Christ of the Latter Day Saints has a staff of sixty designers based in Utah, who design the very extensive range of print and electronic publications and packaging for goods that are a substantial feature of its missionary activities. A group such as Oxfam, dependent upon donations, also needs constantly to promote its cause to generate public support.

Large volumes of materials are also essential to museums, from floor plans of exhibits, to directional signage and the publication of major catalogues. A substantial area of expansion in recent years has been in online museum sites. Some of these simply duplicate information published in other forms, but others, such as the J. Paul Getty Museum in Los Angeles, have begun to exploit

the educational potential of demonstrating the richness and variety of their collections to a much wider audience.

Neither can organizations focusing on political and social protest be ignored. The symbol of the Nuclear Disarmament movement is a classic example of the capacity of such groups to create powerful forms and is almost as widely copied as Milton Glaser's heart. A more recent example is the red ribbon-fold of Aids campaign groups.

On the level of techniques, a feature of communications is the extensive and expanding range involved. This can lead in the direction of both generalized integration and specialization. By the former is meant the way in which different visual elements can be combined in a particular communication. A piece of packaging, for example, might well combine material and structural criteria with illustrative and photographic imagery, a corporate logo, typeforms—combinations of typographic elements—used as expressive elements, brand names and symbols, instructions for use, and product information required by law. On the other hand, as the scale of projects increases, a specific element can frequently require specialist competencies, in a manner akin to the spectrum of abilities required to produce a motion picture. It might, for example, be necessary to combine typography, illustration, photography, information design, or interface design for computer programmes, each requiring specialists in the field.

Typefaces are one of the most basic building blocks in design, and typography—designing and composing letterforms—is a fundamental skill in creating printed imagery. The shape of a typeface can be designed for clarity, intended to communicate with maximum utility, or it can be powerfully expressive or evocative. With the introduction of computers, an astonishing range of typefaces has become available, enabling designers to explore examples from a wide historical and geographical range as well as more recently devised formats. Typefaces combined into words can be powerfully amplified or given a specific nuance by the choice of fount, or be shaped into expressive or decorative forms to serve as highly expressive elements in a design.

Publications come in a range of forms. Books are the archetypal vehicles for disseminating ideas and information. Although their demise has been widely predicted since the emergence of electronic media, they remain portable and convenient for flexible individual use and retain considerable advantages: there is no digital equivalent yet of the terms 'book collector' or 'book lover'. Newspapers and periodicals are more ephemeral and perhaps for this reason are somewhat more vulnerable to competition from electronic media. People often form communities of interest sharing a common sympathy for specific books, such as the Harry Potter series, or for particular editorial policies or standpoints. The visual identity of publications such as *The Times*, *Vogue*, *Rolling*

Stone, or *Wired* is an important element in creating such affinities. On a more intense level, many subcultures have also formed around publications, examples being the work by David Carson, a California designer for *Beach Culture* and *Ray Gun* magazines in the early 1990s. Computer manipulation enabled him to create kinetic images that struck a deep chord in the youth culture market targeted by these magazines.

Illustration, which lies at the artistic end of the communications spectrum, is a core skill distinguishing many practitioners. The distinctive style of Raymond Briggs or Quentin Blake, linked to a great talent for storytelling, has enabled them to carve out careers as author/illustrators. A younger generation of talent is exemplified by Sue Coe and Henrik Drescher. Coe, born in England and now based in New York, has produced print series using traditional techniques such as etching that raise social commentary to a level of burning intensity. Drescher, born in Denmark, educated in America, and now living in New Zealand, has work published in the *New York Times* and *Time* magazine, but his mordant, quirky style is at its best in the children's books he writes. His use of the computer is an outstanding example of the potential of digital technology as a creative tool.

Illustration, however, can also be a very specialized form of work, often requiring considerable technical expertise, as in technical or medical illustration. Some consultancies focus these skills

on a particular outlet, such as educational and scientific publishing, or museum and exhibition display. Photography similarly covers a spectrum from work of the most personal nature to specialized forms for specific purposes, such as documentary photography, or photographing objects for sales or exhibition catalogues and other publications.

One of the most dramatic features of communications is the manner in which many aspects of design are being radically transformed by the growth in multimedia publishing, combining text, images, video, and animation in ways that open up immense new possibilities. The range and flexibility of this new medium are most easily experienced on the Internet. Its potential for direct experience and easy access is still in the early stages of development and there are huge questions of developing forms of typography and imagery specific to electronic publishing, as against simply replicating forms from other media. Above all, as business applications grow, some of the greatest questions requiring greater attention relate to the problems of navigating through complex sites and the vast amounts of information available. The more successful online sites, such as Amazon.com and Travelocity, show both the potential and the limitations of the new medium. They have pioneered the way in opening up possibilities for customers' choices through the design of sites that are very user-friendly. However, at the same time, it needs to be emphasized

Communications

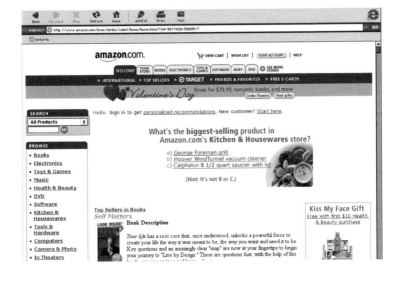

17. Navigating the web made easy: Amazon.com page

that, although information processes are radically different, the product purchased through the process remains unaltered: the design of books and airline seats remains unaffected by such transformations.

The highest levels in sustainable growth arising from the revolution in electronic media have been in business-to-business applications, which have dramatically expanded. The capacity simultaneously to simplify procedures and give access to customers through their computers is opening up huge potential for improving efficiency. Suppliers can store vast quantities of information about products and services, enabling customers to order on a just-in-time basis, instead of tying up capital and facilities in large stocks. The main criterion in the efficiency of such systems, however, is information solutions that are clear, accurate, and comprehensible. If customers cannot speedily navigate through to what they need, a provider will be at a major disadvantage. An important emphasis in such online sites is that virtuoso visual effects are useless if the ability of users to take action is not taken into account.

The complexities of multimedia applications also exemplify a wider characteristic of communications, with innumerable further subdivisions and combinations of skills constantly being generated, such as photography combining with illustration in animated films, or with typography for film titles. The design

practice of Saul Bass was built on the twin poles of film publicity and corporate logos. In the former, he was responsible for such classics as Otto Preminger's *The Man with the Golden Arm*, or Alfred Hitchcock's *Psycho*, in which he displayed an ability to combine various elements—visual imagery, type, and pictographs—with music into compelling sequences. These were the basis not just of titles, but of other publicity materials such as posters and advertising. In addition, he also devised corporate logos for firms such as United Airlines and AT&T. A graphic designer working on large projects might indeed need to know something of each speciality in order to function adequately as a manager of a range of such competencies. Once again, the stereotype of designers as artistic lone rangers can extend in reality into the combined talents of a group or team.

This same stereotype is also placed in question by the field of information design—a highly specialized branch of communications in which data on any subject are presented in ways enabling their use as a basis for decision making. Such information can be presented in many forms and media over a huge range. An everyday example is provided by weather forecasts. Data from numerous sources are rapidly translated into visual forms, enabling decisions to be taken about what clothing to take on a trip or what equipment is necessary for a job. This information is available from maps and text in daily newspapers, from television maps and

animated sequences, or from online sites. The Weather Channel in the USA, broadcasting televised forecasts around the clock, and, in the United Kingdom, the BBC's regular forecasts on radio and television, are supplemented by web sites where detailed forecasts for the whole country, or specific regions or cities, can be obtained for a week hence. On another level, an American web site, World Pages. Com, provides directory information of telephone subscribers throughout North America, supplemented by detailed maps of locations and information on accommodation and facilities in the vicinity of each address. An innovative approach to providing market information is exemplified by Morningstar, a Chicago-based company, specializing in financial data services to facilitate decision-making by investors on sales or purchases of mutual funds. The core task is compressing very large amounts of information into a comprehensible format that, using numerous graphic devices, enables users to make informed and rapid investment decisions. Originally in printed form, information is now available online. The emphasis at Morningstar is on content as the primary need, not aesthetic expression, although the company's total image, by its consistency, does in fact generate a very distinctive aesthetic image.

In contrast, advertising is not primarily concerned with enabling users, but is one of the most specialized areas of persuasive communications, as well as one of the most pervasive, utiliz-

ing a blend of text and imagery to promote products and services. As such, of course, there is a considerable area of overlap between communications and objects, since the latter can be designed for maximum visual impact, with translation into advertising imagery in mind. In this sense, when consistently executed across all elements of a marketing campaign, the advertising image can condition perception of objects before they are actually seen. Most people, for example, will see an advertisement for a new automobile before they see an actual example on the street.

A particular feature of most advertising is that, while attempting to mould opinion, it cannot afford to offend anyone in a particular market, which accounts for much of the bland uniformity of the people and lifestyles it depicts. This had led some critics to depict a stereotypical image of advertisers as the puppet masters of modern society, manipulating everyone to do what is not in their best interest. Most advertisers, however, see themselves as mediating between trends in society and their clients' interests, both reflecting what is happening in society and feeding back a stylized version of it in advertising campaigns and imagery.

The influence of advertising, however, cannot be underestimated, particularly where it has been refined as an instrument of inducing mass consumption. In the USA, where such techniques were first evolved and penetrated deepest, its methods and imagery have become part of the cultural fabric. Even political

campaigns for the presidency or other major offices are run as advertising campaigns, constantly adapting a candidate's image to changing circumstances. Such is the embedded influence of these techniques that the boundaries between image and reality frequently become blurred.

Another vague boundary is that between advertising and propaganda, the latter being a particular form of communication that attempts to shape opinions in support of political or ideological ends. Advertising cannot afford to stray too far from what its target audiences understand as reality, although it can warp perception by selectivity, through what it consistently chooses to emphasize or omit. Unlike advertising, however, propaganda frequently depends upon establishing an image by offending a particular group—depicting them in some stereotypical form as 'the enemy'. Although truth has sometimes been a stranger to advertising, lies and gross distortion are endemic to propaganda.

Clearly, the role of communications in modern society is huge, of deep significance on multiple levels, and in a considerable state of flux and change, with different cultures overlapping, combining, and borrowing from each other. On one level this can be seen as part of the process of globalization, with ideas flowing more freely across national or ethnic cultural boundaries. Even within cultures, however, there is a parallel process of exchange. Professional designers use forms, for example, graffiti, borrowed

from urban street culture movements such as hip-hop or punk, while the public have access to computers or facilities in print shops that encapsulate professional skills in forms available to and affordable for everyone. A negative result has been a diminution of small graphic design businesses catering for local needs, but there are positive aspects from the overlap, as designers reach beyond a closely defined professional definition of their role and the public becomes more involved in communicative activities. If one of the purposes of communication design is to create a sense of identity in visual terms, the capacity of new technology to enhance mutual understanding between those who create images and those who receive them offers considerable potential for the future.

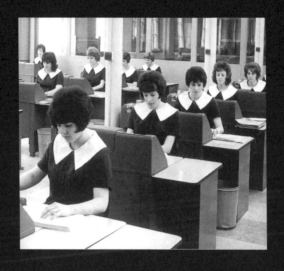

6 Environments

When considering environments, additional layers of complexity come into play. In common with objects and communications, form, colour, pattern, and texture are basic compositional elements, but the articulation of space and light is a specific characteristic of the design of environments. Moreover, in this context, objects and communications become closely interlocked with spatial elements, giving added emphasis to their functionality and significance.

A further important distinction is that environments are frameworks for activities, significantly affecting patterns of use, behaviour, and expectations in home life, work, leisure, and a range of commercial ventures.

In basic analytical terms there is an obvious distinction between internal and external environments. The latter may be considered the predominant domain of other disciplines such as architecture, urban and regional planning, and landscape architecture. In addition, the structures framing interiors are, of course, frequently determined by architects, engineers, and builders. There is, however, a range of environments primarily concerned with specific uses that come within the compass of design and largely distinguish its role from other forms of practice. The spectrum of func-

tions and ideas about their design, however, is huge, and, in a brief compass, little more than scratching the surface of this huge diversity is feasible.

As with other areas of professional specialization, interior design spans a wide spectrum of approaches and professional functions. At one pole are those concerned with the decorative layout of specific spaces and their contents using available furnishings and materials in terms of their overall aesthetic effect, for such settings as private homes for wealthy people, restaurants, or hotels. These tend to be the outcome of stylistic trends and personal taste on the part of designers and clients, and can be considered more in terms of compositions of existing elements rather than design from first principles. At another pole, however, can be found the original creation of spatial concepts and layouts and the specification of equipment for specific purposes, such as offices, hospitals, or schools that have to meet a spectrum of often demanding criteria regarding health, safety, and efficiency.

In addition to this professional dimension, however, there is a feature of the creation of environments that is largely absent in other aspects of design. It is the one area of practice that on some level can involve very large numbers of people in design decisions: namely, in their home. The majority of any population are not involved in the design of the products or communications that

surround them, but the domestic environment is still the prime sphere in which it is possible for people to take design decisions on their own terms. The research of Csikszentmihalyi and Rochberg-Halton, mentioned at the end of Chapter 3, concluded that people invest objects with personal meaning. With environments, this potential for creating personal meaning can not only be invested in existing forms, but can be actively involved in changing existing environments into preferred states. A significant manifestation of this trend is the availability of an expanding range of do-it-yourself products, publications, and television series, providing the means and information for anyone who wishes to transform a personal environment into a mirror of his or her needs and aspirations. The results may sometimes be bewildering. Excesses, such as plastic, imitation wooden beams stuck on to suburban living-room ceilings, or gold-coloured rococo decoration sold by the yard to be applied to the surfaces of plastic-covered synthetic-board furniture for bedrooms, can be comical, even grotesque. There is an important principle in this trend, however, which is often overlooked. The design of books, tools, and materials for such activities encourages people to take control over important decisions regarding their personal environments and, at some level, to be creatively involved in the realization of their ideas. The concepts and techniques involved are not particularly difficult and are within the competence of

most people. Although self-appointed arbiters of taste might find the results of these activities easy targets for derision, they provide a significant example of how design can have an enabling function, facilitating participation by a broad population, in contrast to the more remote generation of professional solutions.

Interestingly, the situation is somewhat different in the USA, where the American Society of Interior Designers had over 30,000 members in 2001, with a substantial proportion specializing in residential design, and with close links to manufacturers of design-related products and services, such as textiles, wallpapers, furnishings, and fittings. In addition, most large furniture and department stores in the USA offer the services of professional designers in their employ to customers requiring assistance in purchasing. One Chicago furnishing retailer alone advertises the services of 200 designers available to customers. The proportion who pay to have their home planned is therefore much higher than in Europe, for example, where, in comparison, the Association of Dutch Designers has 180 members in the category 'environmental designers'. On a population basis, the Netherlands, a prosperous country and an example of design consciousness, has one interior designer per 89,000 people in comparison to one to 8,700 in the USA. One estimate is that a third of American homeowners turn to professional advice in some form in decorating their home. The possible reasons for this are

many, among them, the influence of a mass culture that deskills the population by emphasizing comfort rather than activity, which furthers penetration of the culture by commercialized services, and, more recently, longer working hours by both married partners to maintain income levels, leaving little free time for home-making activities.

Within any society the spectrum of individual solutions in home environments makes it difficult to generalize about patterns. What is more clearly evident are sharp differences between various cultural and geographical circumstances. This can include such factors as whether homes are owned or rented, whether provision is predominantly in the form of houses or apartments, and the amount of space available or considered appropriate for domestic environments.

Again, the USA is an exception, the size of homes having doubled since the Second World War. To a considerable extent, this mirrors the extended range of possessions and facilities considered essential and needing to be accommodated. In terms of global comparisons, so much space is available that little thought needs to be devoted to the precise details of the functional hardware. American appliances such as washing machines, refrigerators, cookers, and bathroom fittings, for example, are large and generally old-fashioned in form and technology, yet inexpensive compared with those designed for European or Asian markets. In

the average American home they can be absorbed into the spatial pattern without substantial thought about how they must be used in relation to competing needs. Multiple bathrooms are not unusual, separate laundry rooms are standard, and, if equipment lacks sophistication, there is the compensating factor of widespread access and affordability.

In comparison, the average Japanese home is tiny compared to those in America and requires detailed thought to accommodate a growing range of desired functions within very limited confines. Consequently, the design of both individual elements on the market and their internal arrangement in the domestic environment is subject to very different pressures. Bathtubs in Japanese homes are often small, for example, intended for a seated or crouched posture, rather than lying recumbent—communal bathhouses giving more space are not uncommon. Toilet and bidet functions are often incorporated into a single pedestal and controlled electronically. Similarly, instead of separate, large washers and dryers, the two functions are combined and miniaturized. Refrigerators are also small but technologically advanced, while cookers are broken down into small modular units to be fitted more easily into kitchen wall storage systems. The latter point also illustrates that spatial limitations force the axial emphasis in Japanese homes to a vertical rather than a horizontal plane—they have to stack instead of spread. In addition, it is still usually necessary for many

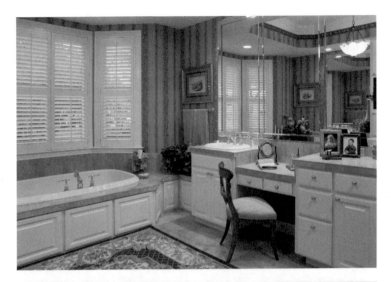

18. Expansion or concentration of the footprint?: American and Japanese bathrooms

functions in Japanese homes to be organised on the basis of convertibility rather than in terms of dedicated space and equipment—for example, with living spaces switching to sleeping spaces and back again.

Within the framework of such general cultural differences, however, the home is still in most countries the one location where anyone can organize an environment to match his or her personal lifestyle and tastes, in a manner not available elsewhere. Although there are, of course, innumerable pressures to follow the fashions manifested in 'style' magazines, manufacturers' advertising and retailers' catalogues, the ability to personalize a space and inject it with meaning remains one of the major outlets for individual design decisions.

In contrast, an overwhelming majority of decisions on how workspaces are organized are made by managers and designers, and the people who work in them have to live with the consequences, with few possibilities for modification. As the twentieth century progressed, concepts of appropriate layouts for manufacturing plants and offices changed in response to changing perceptions of work and its management. With the rise of large corporations in the early part of the century, the ideas of Frederick W. Taylor and his successors in the Scientific Management movement were dominant. The ideas of Taylor and his followers were an effort to assert management control over

work processes by imposing standardized procedures. He advocated finding 'the one best way' for any task and the main tools in organizing workers to fit this pattern were time-and-motion studies. Factory workers became subordinated to manufacturing sequences planned in every detail to maximize efficiency on the basis of mass production. Office workers sat at desks arrayed in uniform ranks, similarly organized and controlled in a strict hierarchy. In some bureaucratic systems, the position and size of desk and chair perceptibly changed with each increase in rank. In both factories and offices work processes were focused on the completion of highly organized functions for known problems and processes.

From the 1960s onwards, some companies began to experiment with looser systems of management, in which, within an overall emphasis on leadership rather than control, workers were encouraged to interact in teams and contribute more actively to processes. In some major Japanese companies, for example, worker contributions to manufacturing processes resulted in huge savings and improvements. The organization of factory spaces reflected this emphasis, with features such as areas of comfortable seating on the factory floor where workers could meet regularly and discuss their work. Such innovations made a substantial contribution to the competitive success of many Japanese companies. A parallel development in offices was in terms of a

concept known as 'office-landscaping', in which layouts became more flexible, with widespread use of partitions to provide a blend of privacy and accessibility in the similar context of ideas about greater worker participation.

As with developments in all areas of design, this sequence in the evolution of ideas has been adopted erratically and all these stages of work organization can still be found, particularly when viewed on a global basis. Even with new technologies, old Taylorist concepts in their worst form can survive. Some companies providing services such as typing documentary information into computers are organized in spaces without windows, to avoid unnecessary distractions, with desks in rigid ranks. Video cameras behind the workers monitor every word and move and computer key-strikes are counted to ensure workers maintain a specified work rate. As in so many instances, the influence of technology does not lead in any specific direction, but is shaped and manifested on the basis of the values informing its application.

The potential for flexibility in many modern technological developments, however, also has many positive aspects that have been widely explored. In contrast to developments in manufacturing plants, Japanese offices can still be crowded, with ranks of steel desks reflecting hierarchical attitudes and the general shortage of space in the country. From the late 1980s onwards, however, construction of a spate of 'smart' buildings was completed,

111

which sought to explore the potential of new electronic technology. The Tokyo City Hall, completed in 1991 to the designs of Kenzo Tange, for example, had twelve supercomputers, with others added later, incorporating sensors that could calculate human activity and automatically adjust lighting and heating levels. They also controlled security, telephone circuits, fire doors, and elevators. The offices typically had partitioned spaces and warm but muted colours. Smart cards gave the 13,000 employees access to offices and could be used for purchases in restaurants and shops in the complex. This was all a great improvement in terms of operating efficiency on previous environments, but did not represent a major advance in concepts of office work.

Some Japanese companies, however, were experimenting with new possibilities opened up by the concept of smart buildings. Research into working patterns showed office workers in Japan typically use their desks for only 40 per cent of the working day. Searching for greater efficiency, some companies introduced more flexible systems of working. Employees might sit at different desks according to the type of work being done to facilitate interchanges with colleagues. Using smart cards, their personal telephone could be routed to any desk.

All this was but a short step to transferring work out of the office. Companies like Shiseido Cosmetics devolved much of its sales activities in the early 1990s, enabling employees to work

from home or regional offices, instead of spending up to four hours a day in long and exhausting commuter journeys at peak hours. Equipped with laptops capable of connection via mobile telephones to the company's main computer, salesmen could instantly access vital information for customers on such matters as availability, prices, and delivery.

While such developments brought many benefits, new problems also rapidly emerged. Devolving work undoubtedly created space savings and thus a reduction of high rents in city centres, but there was still a necessity for employees to work in central offices, even if on an occasional basis. This was particularly true of consulting firms, where many employees spent large amounts of time with clients and might only be in their home office for one day a week, or even one day a month. Many larger companies in the USA, such as Deloitte & Touche, Ernst & Young, and Andersen Consulting, began experimenting with a practical solution known as hotelling.

Basically, this is a space-sharing plan, by means of which workers can contact their home office electronically, reserve a space for a particular time span, and even order food and drink. At the office, personal telephone numbers and computer lines are routed to a reserved desk. A functionary known as a concierge is responsible for installing a wheeled cart containing personal files at the desk and ensuring that all necessary equipment, stationery,

and materials are available. Even items such as family photographs are sometimes set up prior to arrival. On the worker's departure, files are packed in the cart for return to storage, supplies are replenished, the space is cleaned, and it is ready for the next user. The analogies with how a hotel functions are obvious.

Many workers initially had problems with this transient pattern of working, which required radical changes in behaviour and attitudes. It rapidly became clear that such solutions would overcome feelings of deprivation by workers only if levels of investment in technology, particularly software, and support activities were substantial.

The advertising company TBWA/Chiat/Day was an example of the dangers of wholesale change that was not completely thought through. In the early 1990s, it embarked on one of the most extensive experiments in hotelling, which resulted in highly publicized problems. In its Los Angeles and New York offices, the company pioneered large-scale experiments in what was know as 'the virtual office'. After a short time, however, employees rebelled against the pattern of constant circulation, which was increasingly regarded as an unnecessary disruption, and began to claim spaces of their own. In coping with the problems of continuous change in their business environment, it seemed that people needed a haven of stability and security.

Awareness of the imperatives of change in the business world

is, of course, behind the search for new environmental patterns. Many managers, particularly in successful companies, are aware that, in an age of profound change, perhaps the greatest risk is complacency. In particular, with the explosion of information technology, it is clear that the amount of data and information available, which is increasingly exponentially, is of value only if interpreted and applied creatively. Such trends in management thinking are heavily reinforced by changes in manufacturing technology away from mass production towards flexible manufacture for niche markets combined with greater emphasis on attention to services. The result is a new emphasis on innovation as a primary necessity for competitive survival, which hinges, above all, on creativity. This in turn requires employees to be active participants in work processes, bringing their knowledge and experience to bear on problems in rapidly changing circumstances that have few precedents. The result is a move to replace organizational hierarchies and environments that inhibit interaction and communication, with new environments that encourage interchange in a flatter organizational structure, with a careful blend of private and common spaces. Ideas are generated and creativity stimulated, it is believed, through interaction and personal contacts, often on a casual, informal level.

If corporate strategy emphasizes such a culture of new ideas and products, the challenge now in designing work environments

and their equipment and furnishings is how to provide a spatial organization that stimulates interaction and dynamic creativity. The outcome of this complex fusion of ideas emphasizing innovation is to create office environments that are small communities, with a very high degree of potential interaction between disparate elements of an organization.

Learning from its early experiences, in 1999 TBWA/Chiat/Day opened new offices in Los Angeles in a former warehouse with 120,000 square feet of space, designed by Clive Wilkinson. This reflected an interesting change of approach, from the concept of transience implicit in hotelling, to a concept of a community capable of flexibly encompassing different work patterns. The problems of the earlier virtual-office experiment were overcome by giving each employee a personal workstation, but employees also spend a substantial amount of time working in teams in spaces dedicated to major client accounts. The community concept is evident in elements such as neighbourhoods of workstations, a Main Street running through the centre of the space, and Central Park, an area dotted with ficus trees, as a place to relax. The idea is to provide a combination of private, team, and communal facilities on a highly adaptable basis, reflecting the changing nature of accounts held by the company, with the intention of encouraging informal contact and interchange.

A direct contrast to the idea of interior space as adaptive neigh-

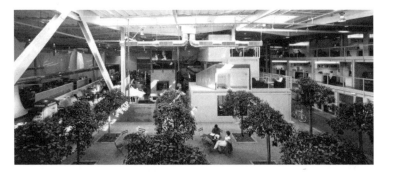

19. Officescape as community: TBWA/Chiat/Day offices in
Los Angeles by Clive Wilkinson

bourhood is another characteristic development of modern life: the exponential growth in standardized environments. In archetypal form, these originated in the USA but have since extended to many other countries. Early examples could be found in upscale markets, such as the growth of the Hilton hotel chain to global prominence, based upon a concept that all their premises should be constructed to a standardized format, intended to enable travelling executives to feel immediately a sense of continuity and familiarity, whatever the location.

The greatest impact of this principle, however, has been through its subsequent spread downmarket on a huge scale. Among the most characteristic sights of innumerable small town and suburban areas of the USA are the 'strip malls' that fill roadsides for miles at a time. These are simply shops, restaurants, and services decanted from earlier concentrations and now spread in seemingly disorganized fashion along main roads, but with easy access for motor vehicles. Within the confusion, however, a high degree of recognition of particular companies exists, especially fast-food franchises. The buildings for, say, McDonald's, Pizza Hut, or Burger King follow a similar pattern across the country, indeed around the globe, which is instantly recognizable. Whatever the specific spatial dimensions of an individual site, the decoration, furnishings, and fittings also provide an immediately recognizable pattern for customers. Similarly, their menus offer

20. The landscape of assertion: US strip malls

highly standardized fare at accessible cost. The role of design, therefore, becomes that of providing a complete template across all activities and design elements, adaptable in detail to particular sites around the world, but always within the framework of over- all standards.

In the United Kingdom or Europe, where space is more limit- ed and planning controls have largely restricted such sprawl, main shopping streets show a similar repetitive pattern, as the same combination of chain stores and food franchises takes over in city after city. The interiors of such diverse companies as Boots, MacFisheries, Mövenpick, or Wienerwald restaurants follow standard guidelines, and, again, embody a familiar pattern, and much the same products, whatever the location.

Another commercial trend influencing many aspects of design during the 1990s, and particularly influential in some categories of environments, was an emphasis on 'experience' or 'fun'—there were even job descriptions in design firms for 'expe- rience architects'. This was part of a wider trend for more and more areas of life to be subordinated to the imperatives of mass entertainment, whether in television or news publishing, in sports such as football or wrestling, in shopping, or in eating out.

British pubs have long been subjected to development as 'theme pubs', as breweries have bought out independent owners and have sought to maximize trade by appealing to particular

trends. Some, for example, try to recreate the feel of Victorian forerunners by such means as embossed wallpaper and cast-iron tables. The Irish brewing company Guinness provides a kit of reproduction items such as nineteenth-century packaging and posters to furnish the rash of 'authentic' Irish pubs that have emerged in major cities around the globe. Yet modern technology also offers the potential of micro-brewing, of beer brewed on the premises, with a highly individual character, in contrast to the standardized products of major brewers.

Similar dichotomies are observable in restaurants. It is still possible in many cities around the globe to find good food served in simple surroundings with unassertive service, as a setting for gastronomic pleasure and conversation. In the USA, however, a growing trend is for restaurants to be designed in terms of a particular theme, say, Italian or Vietnamese, with the service staff regarded as performers following a routine. Eating or drinking in such establishments is not allowed to be an improvisational social experience; instead diners are subordinated to routines under the rubric of entertainment. A synthetic nostalgia can often be a strong element in this emphasis, as in the extreme example of so-called medieval banquets, whose claims to historical veracity are as dubious as the 'authentic fayre' they serve, such as broiler chicken on wooden platters.

Neither is the function of shopping immune from such trends.

21. Shopping as theatre: Niketown, Chicago

A similar spectrum of provision exists, running from what are basically warehouses filled with goods sold on the basis of cost, such as the American retail chain Toys 'R Us, to highly designed environments invoking the mantra of entertainment, such as the Niketown concept, basically a theatre of consumer testing. The first of such premises was opened on Michigan Avenue, the major shopping street of Chicago, by the sports goods manufacturer Nike. It was intended, not as a place to sell products necessarily, since the company's products are still overwhelmingly sold through general trade outlets, but more as a promotional show-piece and test-bed, enabling potential customers to explore the company's range of sports shoes, clothing, and accessories and enjoy themselves while doing so, while their reactions to new introductions were gauged.

The emphasis on providing an 'experience' opens up the design of environments to a bewildering array of forms and themes that are sometimes whimsical and can arbitrarily change with great rapidity. In this process it is easy to overlook the more prosaic but equally vital needs of people in often unfamiliar and sometimes bewildering surroundings. As with all aspects of design, environments are becoming more complex—consider a modern airport such as London Heathrow or Tokyo Narita, which requires more systemic approaches to solutions.

7 Identities

Objects and environments can be used by people to construct a sense of who they are, to express their sense of identity. The construction of identity, however, goes much further than an expression of who someone is; it can be a deliberate attempt by individuals and organizations, even nations, to create a particular image and meaning intended to shape, even pre-empt, what others perceive and understand.

On a personal level, in the world of artifice we inhabit, one of the primary transformations available is of ourselves. For many people, personal identity is now as much a matter of choice as it is an expression of inherited or nurtured qualities, even to the extent of physical transformation—the number of people and amounts of money spent in the USA on cosmetic surgery of one kind or another are reaching staggering proportions. On a less drastic but no less powerful level, advertising continuously exhorts us to be the person we secretly want to be, with images of what we could or should be, a transformation ostensibly achieved simply by buying the proffered product.

The commercialization of personal imagery as a trigger for consumption has resulted in some curious effects as it has spread across the globe. It is possible, for example, for teenagers

in Japan simultaneously to manifest characteristics imbued by an education in the national tradition, and to identify with other teenagers around the world in such matters as clothing, make-up, food, and music. In other words, it is possible to be at the same time a member of one culture and a member of one or more sub-cultures that might have little in common with the dominant form.

While such influences penetrate ever more widely around the world, another transformation is resulting from very large numbers of people migrating to more prosperous countries in search of a better way of life. Modern technology, such as satellite communications, small-scale printing technology, and the Internet, can enable people to be simultaneously functioning citizens of a host society and members, perhaps, of some professional subculture, such as medicine or architecture, while still maintaining intact in homes and localities what they consider to the essential culture of their origins.

Again, how this works for individual people is largely a matter of choice. While the reach and flexibility of modern communications makes it possible for migrants to stay easily in contact with a distant home culture and so sustain and reinforce their original sense of identity, they simultaneously slow any need to assimilate and come to terms with the very different conditions of the host culture. It can create a sense of richness and diversity in the host

country, but obvious differences, visual differences in particular, can also become an easy target for resentment.

Another facet of the construction of identity stems from the large number of nations created by decolonization since the Second World War or freed by the collapse of the Soviet Empire in the late 1980s, resulting in a search for symbols to express the sense of new-found independence. Mythical and often aggressive creatures from heraldic sources—eagles, lions, and griffins—are frequently juxtaposed on coins and banknotes with images of bounty, such as smiling maidens in folk costume, bearing sheaves of grain. Here too, identity is seemingly a matter of choice from a range of possibilities.

Even in older established nations imagery can erupt as a matter of concern. Redesigns of the female figure of Marianne, the symbol of France, inevitably stimulate a barrage of passionate argument. Among the most bizarre features of the United Kingdom as the twentieth century faded were proposals to 'rebrand' the national image, of how the country was viewed by foreigners, in terms of a more up-to-date concept of 'Cool Brittania'. The resulting altercation—the term 'debate' would exaggerate the level of exchange—between dyed-in-the-wool conservatives defending the status quo, and those advocating a marketing-based model that everything should be changed to be 'cool', was inevitably inconclusive. Perhaps the fatal mistake of

22. Inventing tradition: the national identity of Slovenia

the advocates of rebranding was a failure to understand that commercial ideas cannot just be dropped into other contexts and expected to succeed. Arrogant assumptions that the world of business is the 'real world', as it is frequently termed, and its concepts thus a model for the whole of life, rest on gross oversimplifications. In practical terms, it is far harder for any government to control all the aspects of a society, even under a dictatorship, than it is for a commercial corporation to establish control over its product and services and so establish a brand.

Disputes about national identity may be bizarre, but there can be little doubt of its power to motivate, even in industrial countries when there seem few causes left to engage people. Another example from the United Kingdom in the 1980s was a profound reaction to the introduction of new telephone kiosks, following the state-owned telephone services being privatized as British Telecom. BT set out to define its independent status for the populace by replacing the long-established, bright-red telephone kiosks across the country. A new version, basically a glass box, was bought off-the-shelf at low cost from an American manufacturer. The new kiosks were claimed to be more efficient, which in many respects they indeed were. The models they replaced, however, had been used since 1936, becoming a distinctive icon of British identity, widely used on travel posters and tourist publicity, and the decision generated an astonishing outburst of public outrage.

British Telecom has since commissioned several redesigns of their kiosks, but without ever entirely mollifying resentment at the removal of a very familiar and unique element of the cultural landscape. Such reactions to change may be based on nostalgia, with, in this case, more than a leavening of irrationality, but the problems are real.

The influence of cultural differences on design practice is one of the most profound problems thrown up by the growth of globalization. Problems arising from cultural differences can be a minefield for companies with ambitions to extend markets. The American appliance company Whirlpool had to learn how to evolve a global/local approach to product development on the basis of product concepts adaptable to different countries. With a lightweight 'world washer' introduced in 1992, it was necessary to accommodate washing 18-foot-long saris without tangling in India, and to add a soak cycle for Brazil to cater for the local belief that only pre-soaking can yield a really clean wash.

In contrast, Gillette has been highly successful on the basis of a belief that cultural differences have little effect on shaving. Instead of spending millions to alter its products to suit the tastes of different countries, Gillette treats all marketplaces the same and tries to sell the same razor to everyone, a strategy that has been widely successful. The factor of culture is obviously linked to the

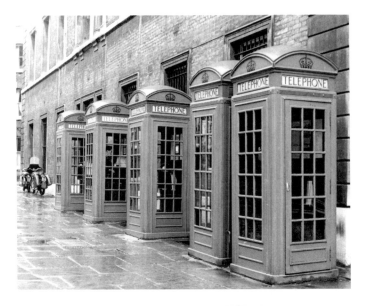

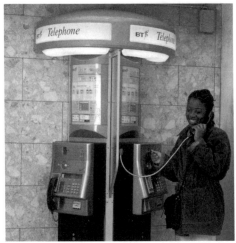

23. Defending tradition: old and new BT telephone kiosks

specific patterns of how particular products are used. General, global patterns may be applicable to some products, particularly the simpler functions, but others may require detailed adaptation. Demand for specifically different products may even be a factor in some markets.

A dilemma in designing across cultural boundaries, therefore, is the extent to which cultural identity is fixed or is capable of change. The problems of miscalculation can be severe, as is attested by widespread reactions in the name of protecting cultural identity against the patterns of cosmopolitanism, and particularly the freer flow of trade and communications characteristic of globalization.

Two points are worth emphasis in this context. First, there are enormous opportunities to affirm the particularities of any specific context and to design for them in ways not obvious to global organizations. In Korea, refrigerators are designed to accommodate fermenting kimchee, a traditional, spicy, pickled cabbage indispensable to Korean cuisine. In Turkey, the dolmus, a small minibus, is used for very flexible public transportation, even door-to-door. When expensive imported vehicles were found ill-suited to local needs, an industry emerged that developed models suitable for local conditions, to the extent of customizing a dolmus to the needs of any particular operator.

Secondly, while penetration of markets around the world

provokes a need to affirm local identity in terms of specific needs, there is a countervailing need for global businesses to adapt to the enhanced scale and diversity of markets involved. If new possibilities are feasible or desirable, a major question for designers is how to enable people from different cultures to navigate the problems of change. In other words, business should respond to different cultural needs in ways that improve lives: by designing products and services that are accessible, appropriate, understandable, and pleasurable, in ways they can absorb into their pattern of life. Cultural identity is not fixed, like a fly in amber, but is constantly evolving and mutating, and design is a primary element in stimulating the awareness of possibilities.

Above all, the agency that in design terms dominates discussion of identity is the modern business corporation, which spends huge sums of money on projecting a sense of what it is and what it represents. Corporate identity has its origins in military and religious organizations. The Roman legions, for example, had a very strong visual identity, with uniforms and eagle-standards bringing coherence to a body of men, as an expression of their common discipline and dependence. The first modern example was the Spanish army of the seventeenth century, which similarly introduced standardized dress and weaponry to enhance its feared reputation. On another level, the Catholic Church has probably

the longest continuous organizational identity, based on the Imperial Roman hierarchy and clearly apparent through visual means, such as regalia and insignia.

Prior to industrialization, most business units were very small; even those with ten to fifteen people were considered to be of substantial size. Only a few businesses, such as shipyards, employed larger numbers. By the nineteenth century, with the evolution of large business enterprises, often spread over wide geographical areas, a need evolved for some common identification amongst employees that could also be projected to the public. The Midland Railway, a major company in Britain, for example, had 90,000 employees by the late nineteenth century and, through liveries for its rolling stock, typographic and architectural styles, and uniforms for employees, brought an overall coherence to its far-flung operations.

The emergence of mass manufacturing in the early twentieth century confirmed the dominance of big corporations. In 1907, the architect and designer Peter Behrens was appointed Artistic Director of the German electrical giant Allgemeine Elekrizitäts Gesellschaft (AEG), with total control over all visual manifestations of corporate activities. In this role, he was responsible for the design of buildings, industrial and consumer products, advertising and publicity, and exhibitions. A typeface he designed was used for the corporate logo of the company initials, brought unity

to all printed matter, and is still the basic element of the company's visual identity.

More recently, Olivetti and IBM evolved as model examples in the period after the Second World War, although in very different ways. Olivetti, manufacturing a range of electrical and later electronic equipment in Italy, developed an approach in which consistency was not an essential ingredient. Instead, a number of distinguished designers were recruited, including Mario Zanussi, Mario Bellini, Ettore Sott sass Jr., and Michele de Lucchi. The company gave them substantial freedom and extensive support in their work, relying upon each particular item being an outstanding design in its own right, in the belief that the overall image of the company would thus be of continual creativity rather than conformity. Even the corporate logo changed with remarkable frequency. A remarkable feature of Olivetti policy was that the company did not employ designers on a full-time basis, but insisted they spend half their time working outside the company in order to stimulate creative vitality.

At IBM, designers of great ability were similarly used—Paul Rand, Charles and Ray Eames, Mies van der Rohe and Eliot Noyes, to name but a few. In contrast to Olivetti, however, the pattern was more tightly structured, with strict guidelines and standard specifications within which products and publications were designed. For a time, even employees were expected to con-

form to a dress code considered a desirable aspect of the overall corporate image.

By the early 1990s, Olivetti had serious problems in adapting to new technologies and products and the role of design in the company diminished. Ultimately, not even a stream of brilliantly designed products and communications could save the company from the consequences of inadequate responses to change—underlining the fact that design alone, no matter how outstanding, cannot guarantee business success. IBM was similarly hit by the emergence of highly competitive personal computer manufacturing companies, but maintained high standards in its design guidelines. In the 1990s, it began to regain ground and once again generated notable products, such as the Think Pad portable computer designed by Richard Sapper in 1993, and the Aptiva desk-top models. These were statements of intent that the company was still a major player, with design as an integral element of how it projected itself.

Although many identity programmes have evolved over a long period and have been incrementally updated while retaining an original flavour, such as the scripted Ford logo, it is sometimes surprising how rapidly other images can become established. One of the companies creating problems for IBM in the early 1980s was Apple, which under founder Steve Jobs evolved a striking corporate identity, with a rainbow-coloured apple logo and a

commitment to design in all aspects of business. The Macintosh personal computer set the standard for ease-of-use in interface design, and even its packaging was exceptional. The box in which the Macintosh was delivered was so intelligently designed, with each item sequenced with clear instructions on where it went and how it connected, that unpacking was synonymous with successful rapid assembly and readiness for use. Subsequently, although the competitive position of Apple has fluctuated in what is the most volatile of industries, the commitment to design and innovation has remained substantial and integral to how it projects itself.

Identities have been even more rapidly established with the advent of electronic commerce using the Internet. It is often overlooked, however, that corporate identities, while profoundly important in creating a sense of instant recognition, and indeed trust, among prospective purchasers, can succeed on a sustained basis only if a distinctive visual image is underpinned by commitment to quality in products, operations, and services. This point is, if anything, even more true of service organizations. Federal Express, for example, founded in 1973, opened up a new market for the air freight of documents and packages. Twenty years later, with a fleet of over 450 aircraft and some 45,000 vehicles delivering around the world, the company realized its original logo did not reflect the reputation it had built for speedy and reliable serv-

ice. Landor Associates was asked to suggest changes. A decisive point in the process was the realization that the company had universally become known as FedEx—indeed, the term was even used as a verb—and it was this that was chosen for the logo. It enabled a much bolder statement to be made on aircraft, vehicles, signs, and documents, and its simplicity not only communicated with greater clarity, but also cost significantly less to implement in terms of painting and printing costs than the earlier form.

The new identity, however, would have been ineffective had it not been backed up by efficient services, and, to emphasize this point, the roll-out of the new visual identity in 1994 was timed to coincide with another innovation. The introduction of bar-coding made possible a new proprietary software, FedEx Ship, to be made available to customers, with a simple interface enabling them to track or ship their packages. Previously, if customers wanted to know the whereabouts of a package, they would have to telephone FedEx (at the latter's expense) and employees would try to locate it while the phone bill mounted and customers became impatient. The new software gave better service by putting access and control in customers' hands, while saving FedEx substantial sums of money in operating costs.

A new visual identity can also be a signal of a major change of intent in corporate strategy. In the year 2000, British Petroleum (BP) unveiled a new identity programme that featured a dramat-

24. Clarity and cost-saving: FedEx redesigned corporate logo by Landor Associates

ic image of a stylized sun-symbol in the long-standing corporate colour scheme of yellow and green, again by Landor. Accompanying advertising signalled a move to a wider pattern of activities, under the slogan Beyond Petroleum. This brought down on BP the wrath of environmentalists, who pointed out that the corporation's business remained overwhelmingly petroleum based. Whether the new image will be sustainable depends in great measure on the behaviour of BP in the future and the extent to which it can be judged against its claims for itself.

Changing a corporate identity can raise huge expectations but sometimes disastrously fail to deliver. The redesigned identity of British Airways (BA), by the London firm of Newell & Sorrell, launched in 1997, cost some £60 million. Its launch unfortunately coincided with a dispute with cabin staff, many of whom went on strike, resulting in cancelled flights, which was unfortunate, to say the least, for a organization projecting the quality of its service. A controversy also arose over a detail of the new identity, a decision to feature ethnic art from around the world on the tails of aircraft in an effort to reposition the carrier as an international, rather than a British, company. The tail art programme received some praise but also considerable ridicule and has since been quietly dropped, with a stylized version of the British flag replacing it. The problem of positioning is a real one, however, since 60 per cent of BA's passengers are non-British. Ironically,

despite some farcical aspects of the new identity launch, such as the former Prime Minister, Lady Thatcher, attracting the attention of the press by ostentatiously draping a handkerchief over the ethnically decorated tail-fin of an aircraft model on exhibition, the design programme of BA is one of the most intensive of any of the world's airlines. It has delivered some genuinely successful innovations, such as seats in first and business class accommodation that convert into beds. In reality, the perception of BA in its target markets was in practice better than the unfortunate publicity surrounding the launch.

This illustrates what is probably the greatest problem in the field of corporate identity: a frequent confusion between image and identity. The former refers to the visual imagery enabling customers easily to recognize a particular company, obviously a desirable and necessary function; the latter, however, relates to how that image is understood by customers, or their expectations of the company. Image is a projection of how a company would like to be understood by customers; identity is the reality of what a company delivers as experienced by customers. When the two are consonant, it is possible to speak of corporate integrity. If a gulf opens up between the two, however, no amount of money flung at visual redesigns will rebuild customers' confidence. Put another way, image is credible only when supported by a good product or service. A good product or service, however, does not

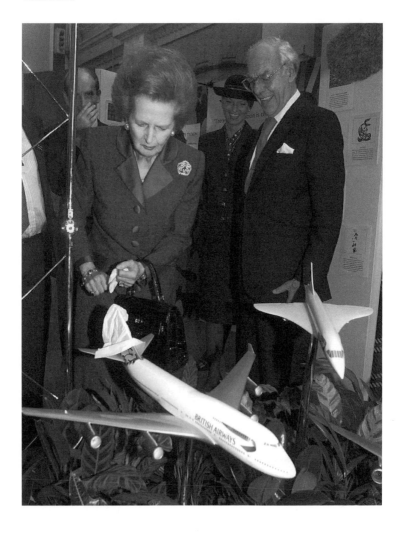

25. The risks of change: Lady Thatcher covering up the new
BA identity with a handkerchief

necessarily require an expensively contrived image. The optimal situation is when good products and services are complemented by consistent communications of high quality and reliability, when identity is the image.

8 Systems

The growing emphasis in design on systems of various kinds, in contrast to a focus on dedicated forms, stems in part from an awareness of the growing complexity of modern life, with multiple interconnections and overlaps between elements influencing overall performance. The spread of technical infrastructure systems is basic to modern life, as witness the failures of electricity supply in California that began in late 2000. The role of information technology in increasing awareness of connections between disparate functions (as well as increasing consumption of electricity) has also been profound. On another level, enhanced awareness of the environmental consequences of human intervention in natural systems and of the resultant concepts of ecological, organic relationships is also a contributing factor.

A system can be regarded as a group of interacting, interrelated, or interdependent elements that forms, or can be considered to form, a collective entity. The collective quality in its relationship to design can be manifested in various ways. Different elements can be combined in ways that are functionally related, as in transportation systems; by a common network of structures or channels, as in banking or telecommunications systems; or as a coherent structure of compatible elements capable of flexible

organization, such as modular product systems. A further charac-
teristic of systems is that the pattern of interrelated ideas and
forms requires principles, rules, and procedures to ensure har-
monious, orderly interaction. This requires qualities of systemat-
ic thinking, which infers methodical, logical, and purposeful
procedures.

When designers have approached the problems of such systems
in terms of formal, visual solutions, carrying over approaches to
less complex tasks, these have often failed dismally to address the
real problems of adapting to new requirements. As so often in his-
tory, new technologies tend to be defined initially in old forms
and a transition period often seems to be necessary before new
forms are evolved. Typical examples are the horseless carriage
before it developed into the automobile, or desk-top computers,
basically a television screen and a typewriter keyboard, which still
await resolution. This is certainly the case with many systems
which have tended to evolve in response to practical needs in the
first instance, and only subsequently evolved to a level where they
were considered systematically. Initially, cars existed in isolation,
needing to carry fuel for long journeys and with personal owners
responsible for repairs. Outside cities they ran largely on unmade
roads. Only later did a systematic approach to road construction
and maintenance, information systems, and support systems such
as those providing repairs, fuel, and refreshment come into being.

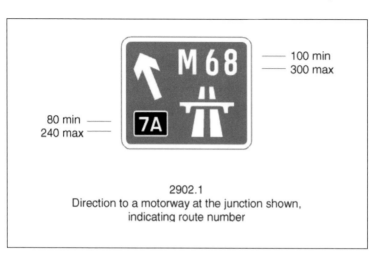

2902.1
Direction to a motorway at the junction shown,
indicating route number

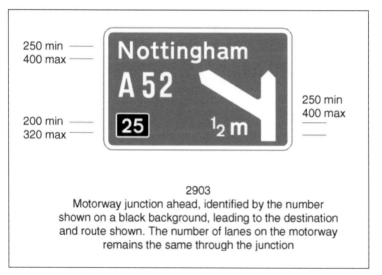

2903
Motorway junction ahead, identified by the number
shown on a black background, leading to the destination
and route shown. The number of lanes on the motorway
remains the same through the junction

26. Defining standards: British road sign system templates, UK Department
of Transport

Systems

It took half a century for coherently planned systems of high-speed roads, variously known as autobahns, motorways, or freeways, to become an accepted component of motorists' expectations.

In addition to the physical aspects of systems, information obviously plays an important part in communicating to users. One particular feature of road networks—road signage—illustrates some key features of design in a systems context. Each directional sign on a road network gives specific information in relation to the particular geographical point at which it is located and connections therefrom. They are not individually designed, however, but instead conform to a standard specification determining the size of each sign, the typeface and symbols used, and the colours in which they are displayed. In the United Kingdom, for example, motorway signs are blue with white letters; other major roads use dark green with yellow letters indicating road numbers and white letters for place names; for minor roads, signs are white with black letters. The format of signs is therefore strictly standardized to enable rapid recognition. Each sign gives highly specific information coded in a manner that can simultaneously be related to the system as a whole. The purpose of such a system is to give clear information about the consequences of taking a particular turning or direction, but leaving users to decide on exactly where they wish to go. It should be added that compatible, not

necessarily identical, systematic approaches to other forms of information, such as maps or on-board directional computers, are also crucial to users' ability to navigate the system.

Directional signs are also supplemented with a system of road-side signs using symbols and pictographs covering a wide range of other purposes. International standards, as in Europe, have in some cases been established for this category. An important basic distinction is between communications requiring compliance and those facilitating decision making—between 'No Entry' or speed restriction signs, intended to prevent or control action, and those warning of potential hazards or problems, such as indicating school crossings or sharp curves in the road that require decision making by users.

Above all, the effectiveness of any system will depend upon its overall coherence, with clear standards enabling users rapidly to understand and navigate their way through without undue prob-lems. This is particularly true of new systems based on innovative visual conventions requiring a degree of learning and adaptation by users. Computer programs are running into considerable problems in this respect, as designers attempt to create more and more icons intended to serve as a visual shorthand, with inevitable difficulties resulting from overload and lack of clarity.

Transportation provides other prime illustrations of the need for systemic approaches, as in, for example, the subways or mass

rapid transit systems typical of many major cities. As with the example of automobiles and road systems, understanding the systemic nature of urban transport systems initially evolved on a piecemeal basis before a detailed concept of it emerged after much trial and error. In this respect, the development of London Transport from the turn of the twentieth century to the Second World War is a key case study. Under the managerial leadership of Frank Pick, the organizational unification of disparate parts led to the establishment of systemic approaches on a number of levels, initially in terms of a common logo, typography, and signage, then to standard designs of trains, buses, and station fittings. Communicating an understanding of the system to users was significantly enhanced with the London Transport map designed by Harry Beck in 1931, a masterpiece of information design. Although not officially commissioned (Beck designed it in his spare time), it has been remarkably successful in enabling people to understand the system as a whole in a clear and unequivocal manner, subsequently imitated all over the world.

What any urban transport system illustrates is that the overall pattern can be broken down into subsystems in order to strike a balance between coordination and specific requirements. On one level are the problems of physically linking places and transporting people between them, which requires technical coordination of diverse elements for effective operation. Typically also, differ-

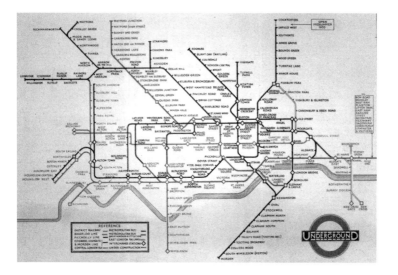

27. A pattern for the world: Harry Beck's London Transport map, 1933

ent kinds of vehicles, communications, and environments will be required, and standard approaches to each can provide considerable benefit in operation and maintenance. It is also possible to think of such systems not just in the sense of physical communication, but also as information systems. The latter concept focuses on the standpoint of users and their encounters with the range of functions and services. Observations of patterns of use can enable generic concepts to be established as a basis for common standards to be established across the system for the communication of information.

This can be illustrated by the diversity of forms encountered when taking a trip on a train or subway. Identifiers indicate the presence of a facility, for example, in the form of a sign over an entrance to a station, which the public can use if it so wishes. Information is provided about services in the form of maps, timetables, and fare tariffs. Instructions will be necessary to enable users to gain access, by buying tickets from automatic machines or from a kiosk. Further instructions will direct users into the facilities, to platforms for trains on various lines or directions. Restrictions will also be a part of the system, such as signs preventing users from entering operational sections, or those forbidding smoking. Further information on trains and identifiers on stations will be necessary to enable users to know when to leave trains. Stations can often be decorated with aesthetic imagery

such as murals or mosaics intended to provide diversion and stimulus for travellers, while on the trains themselves, there may be other examples of expression, free-form individual communications, such as prints or poems, among the inevitable advertising. Even propaganda by organizations attempting to compel a shared belief is found. On leaving a train, instructions to make a connection or exit the facility in a particular direction, supplemented by maps of the vicinity, can enable users to become quickly oriented to the environment. The pattern of communications can be complicated in countries where one or more languages are in official use. In the Hong Kong Mass-Transit system, all signage uses English as well as Chinese ideograms.

In addition, of course, there is a similar pattern of environments and objects that interrelate with communication forms to constitute the system as experienced by users. Automatic ticket machines and the trains themselves are examples of the former, while booking halls, waiting rooms, corridors, and platforms are typical environments. The most effective systems in terms of ease of use are those that have patterns of consistency and standardization throughout the system, enabling users to know what to expect and sustaining a sense of security and familiarity. Designing to meet such needs requires the coordination of a broad spectrum of means—signs, spaces, vehicles, sound—that enable users easily to navigate any complexities. The Metro sys-

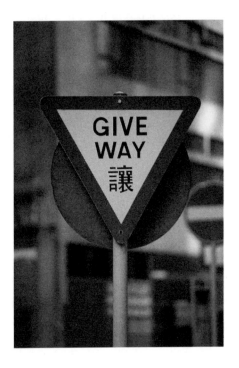

28. Coping with diversity: Hong Kong dual language road signage

tem in Lisbon, for example, has a repetitive pattern on station platforms of grouping together maps of the system set in the context of the city's geography; diagrams of Metro lines, clearly indicating the component elements of the system; and detailed maps of the immediate environment of each station. In the Tokyo Subway, maps of the system follow the London Transport pattern of abstraction and colour-coding for different lines, but take the logic one step further. Station signs and notices for each line are also in the colour of the line, and strips of colour are used along corridors and passages to give guidance to passengers seeking to connect to particular lines.

A particular advantage of such standardization is in the category of communications that embody specific provision for people with disabilities, which can be on the simple level of indicators, signs, and elevators available for people in wheelchairs. On a more complex level are the problems of people who are blind, for whom, of course, visual signage is redundant. The Tokyo Subway is typical of many systems that have adopted tactile means of communication, with stations featuring strips of tiles with raised dimples running along the centre of floor surfaces in corridors, enabling blind people using a stick to find their way. The pattern of tiling, and the feel of it, alter to signal junction points where more than one path is available. Special automatic machines with Braille instructions and buttons to summon help in case of diffi-

culties are positioned at key points to assist in obtaining tickets and navigating the system. The tiles also lead to platforms, where their configuration orients blind users towards the doors of trains. The provision for the blind can indeed be considered as a subsystem within the greater whole.

Other levels of systems approaches in design that have grown rapidly recently are evident in the development and manufacture of products. New problems in this regard have emerged with the spread of globalization and regional economic unification, such as the European Union, which has amplified the need to bridge different markets and cultures.

Globalization, in particular, has placed greater emphasis on the seemingly conflicting demands of achieving economies of scale through greater commonality between products, while at the same time being able to adapt to the detailed requirements of tastes and compatibility in specific markets. This has taken several forms, but underlying them is a shift from standardized products to standardized components that can be flexibly configured to provide a variety of forms and satisfy a range of needs.

Early mass production was highly inflexible and worked most effectively when producing a standardized product in large quantities. Even variations on a relatively simple level could unduly complicate procedures, such as producing cars for different markets that required, for example, a switch between left- and right-

hand drive. One solution was a principle known as centre-line design, which means configuring the design of a vehicle on either side of a central line, enabling it to be flipped to suit the driving practices of any particular market, but even this variance was costly and disruptive.

Design for mass production tends to be for discrete products, the performance of which is defined in a form that integrates specific assemblies for a particular purpose. It is a lengthy process, and this specificity, allied to individual styling, creates differentiation in the market. A new product requires an equally lengthy, and costly, process. Changes in manufacturing technology, however, particularly the trend for flexible production methods to supplant mass manufacturing, offer radically different approaches to design. These have in common a shift in emphasis from finished products to processes by which products can be generated and configured rapidly. A means of achieving this is the configuration of key elements of a product category into standardized components, with, equally importantly, standardized interfaces or connections. This enables systems to be developed that give users greater choice in adapting products to their own perceived needs, a process to which the label of mass customization, seemingly an oxymoron, has become attached.

An early example was the National Bicycle Industrial Company of Japan. It established a system whereby dealers could offer cus-

tomers the opportunity to specify a bicycle model, for which customers' dimensions could be measured, and their colour preferences and additional components determined. When National received specifications, a computer capable of generating eleven million variants of models printed a blueprint for the customer's bicycle to be produced from a combination of standardized and cut-to-fit parts. The made-to-order model was delivered with the customer's name silk-screened on the frame.

Motorola's organization of pager production in its factory at Boca Raton, Florida, follows similar principles, being estimated to offer customers the capacity to produce some 29 million variants of pager. Production of a customer's model begins some fifteen minutes after an order has been placed at any point in the USA and is shipped the following day. An advantage for producers of such just-in-time manufacturing is the elimination of capital being tied up in inventories. For customers, the opportunity to specify the exact details of products they wish to purchase clearly delivers enhanced satisfaction.

In producing printers for widely different markets around the globe, Hewlett-Packard's approach to mass customization has been to focus on delaying any product differentiation until the last possible point in the supply chain, requiring the product design to be integrated with and adaptable to delivery processes. A basic product is delivered to a supply point nearest to customers, and

is there configured to meet the specific requirements of the particular context, such as compatibility with the local electrical systems.

Flexible configurations are taken to a further level with the introduction of modular units. This means breaking down the overall structure of a product into essential functional components and interface elements, which are grouped in standard modular units, with further definition of add-on optional elements, enabling a large spectrum of products to emerge. Modularity enables each unit to be tested and produced to high standards of quality, and then be used in variable configurations to generate a flow of products adaptable to different markets or, again, to be customized to the particular specification of individual users. The establishment of modular systems switches attention from the finished product as the essential conceptual starting point to the design of processes within an overall systems concept.

On a fundamental level, a popular example of modularity remains the Lego plastic building blocks for children, developed in the late 1940s by Ole Kirk Christiansen of Billund in Denmark from earlier wooden blocks, which epitomize the astonishing variations possible from a rigidly standardized geometric format.

The origins of modular systems go further back, however, and appeared in designs for unit furniture as early as the first decade

of the twentieth century on the basis of standardized dimensions of length, breadth, and height. They became common in the 1920s, enabling unit furniture to be adapted to any size of home or grouping desired by users. By the 1980s, kitchen systems by German companies such as Siematic and Poggenpohl were widely available in Europe. Customers could select a range of modular units to fit their particular space and needs, and a computer simulation could be created at the sales point, with a three-dimensional image showing the final effect and enabling choices on units or colour finishes to be adjusted. Once the choices had been finalized and the order completed, the specification was sent via computer to the factory, where the units would be made to order, again saving on the need for expensive stocks and warehousing.

Modular systems have been very widely used by electronic manufacturers to generate prolific variations of audio and visual products. One of the most spectacular applications of modular systems in this sense, however, has been by Dell Computers, which has harnessed modular designs to the potential of the Internet as a communications device, to define new dimensions of competitiveness. The company web site allows buyers to use the Internet or telephone to order a computer to their specification, which is then built to order from an array of modular components, allowing customers to follow its progress through to

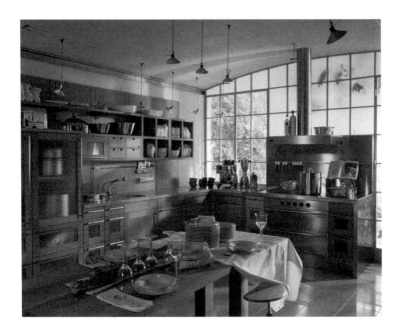

29. Diversity from unity: Siematic modular kitchen system

delivery. The savings for the company from not having components locked up in large inventories have been huge, which makes it possible to establish substantial price advantage.

A further elaboration of such procedures is the concept of product platforms. These platforms group modules and components to serve a basic functional purpose, from which it becomes possible rapidly to develop and manufacture a variety of product configurations. This enables a basic idea to be modified rapidly in response to changing market or competitive conditions. A successful example was demonstrated by Sony after the initial favourable reception of its Walkman, launched in 1979, with the development of a basic functional module and an advanced features module. Each was the basis of warding off competition from followers, enabling a rapid succession of models to be launched to test a wide variety of applications and features at different levels of the market.

While Sony used platforms to stay ahead, Kodak used them to catch up in its response to the introduction in 1987 by the Japanese company Fuji of a single-use 35mm camera. It took Kodak a year to develop a competitive model, yet by 1994 it had captured 70 per cent of the American market. Although a follower in this particular category, Kodak launched more products, more cheaply, than Fuji. Again, a platform concept was the basis of this success, with economies yielded by common components

and production processes, on the basis of which a series of such cameras could be launched rapidly onto the market.

In 1995, the Ford Motor Corporation embraced the platform philosophy when it embarked on a long-term programme of restructuring the company as a global organization. Product development was henceforth to be focused on vehicle types on a global basis, rather than specific vehicles for particular markets. This was intended to reduce product development costs, which in the auto industry have reached staggeringly high levels and can be justified only by markets of global dimensions. A platform product approach would enable Ford to manufacture components anywhere in the world wherever they could be most cheaply and efficiently produced, as the basis of a range of standard vehicle concepts. These in turn could be the basis of differentiated adaptations for particular markets, which could be rapidly developed as specific needs were identified.

These systems of development and design resolve the apparent contradiction between the need to manufacture products in high volumes economically and the desire to tailor them to meet the needs of individual customers. The aim is to exploit the juxtaposition of distinctiveness and commonality to deliver specific solutions through a cost-effective production system.

Other advantages of such approaches can be seen in the possibilities offered to provide greater value to users in terms of fol-

low-up services. When Canon first produced its small personal copiers, it lacked a chain of service outlets. The problem was resolved by designing printing ink refills in combination with elements needing frequent servicing in a common module. Effectively, every time the ink was renewed, the machine got a new engine, so drastically reducing the need for repairs.

Perhaps the greatest challenge facing designers, however, is the need for greater compatibility between the artificial systems generated by human creativity and the systems of the biological world, the result of millennia of evolution. If we can understand the nature of systems in terms of how changes in one part have consequences throughout the whole, and how that whole can effect other overlapping systems, there is the possibility at least of reducing some of the more obvious harmful effects. Design could be part of a solution, if appropriate strategies and methodologies were mandated by clients, publics, and governments to address the problems in a fundamental manner. Sadly, one must doubt the ability of economic systems, based on a conviction that the common good is defined by an amalgam of decisions based on individual self-interest, to address these implications of the human capacity to transform our environment. Design, in this sense, is part of the problem. It is a subsystem within wider economic and social systems and does not function independently of these contexts.

9 Contexts

In broad terms, three areas of contextual influence are relevant to design practice: the professional organization of design, or how designers view themselves; the business context in which a majority of design practice is located; and, in addition, the level of government policy, which varies between countries, but in many can be a significant dimension.

Mention has already been made of the fact that design has never evolved on the level of a major profession such as architecture, law, or medicine, which have self-regulating rights that control entry and levels of practice. Indeed, such is the diversity of design practice and the variety of work involved that it is in fact doubtful if design should, or even could, be organized on this basis.

Nevertheless, professional societies have been formed in a great number of countries to serve a particular specialization or a general grouping of design capabilities, and these can represent the interests of designers to governments, industry, the press, and public, and provide a forum for discussion of issues relevant to practitioners. These may be skill specific, as with the Industrial Design Society of America, or the American Institute of Graphic Arts, or more general, as with the Chartered Society of Designers in the United Kingdom. There are also international organizations

that hold world congresses where design issues across boundaries can be addressed.

Design organizations may make statements on how they view their work, and make recommendations about standards in practice, but the reality is that decisions about such matters are not taken by designers alone. Apart from private experiment and exploration for their own interest, a necessary function in sustaining creative motivation, most designers rarely work for or by themselves: they work for clients or employers, and the context of business and commerce must therefore be viewed as the primary arena of design activity. Ultimately, these clients or employers have the major voice in determining what is possible, feasible, or acceptable in design practice. Business policies and practices are therefore fundamental to understanding how design functions at the operational level and the roles and functions it is able to play.

There are problems in analysing business approaches to design, however, since specific statements on its role in the overall strategy of companies are comparatively rare. The positioning of design in corporate hierarchies is similarly inadequate as a guide, because of the immense variations found—design can, for example, be an independent function, subordinate to engineering or marketing management, or part of R & D.

How design actually functions is to a very large extent based on

implicit approaches specific to each organization, based more on the inclinations of personalities and habitual behaviour. Out of all this diversity, however, some general patterns can be distinguished.

On an organizational level, design can be a central function or dispersed throughout an organization. A company such as IBM was long famous for tight central control over what products were generated and how they were marketed. In contrast, a conglomerate such as the Japanese electrical giant Matsushita devolves such control to divisions specializing in particular product groups, such as TV and video or household appliances.

In some companies there is a very clear distinction between the contributions of design based on long-term or short-term approaches. In the automobile industry, the German company Mercedes emphasizes long-term approaches, believing that its vehicles should still be recognizable whatever their age. This is ensured by centralized control of design and an insistence that each new model retain a continuity of characteristics that clearly identify it as a Mercedes. In contrast, General Motors has a policy of short-term change, with devolved design responsibility to divisions manufacturing under different brand names—such as Chevrolet, Buick, and Cadillac—and an emphasis on constant differentiation through the device of the annual model change. In the case of conglomerate organizations linking several companies,

both product decisions and design implementation will usually be devolved to the constituent units. This is typified by Gillette, which, in addition to its major focus on toiletries, also owns companies such as Oral-B, specializing in dental products, Braun, manufacturing electrical products, and Parker Pens.

In the field of service organizations, airlines, banks, and franchise organizations such as fast-food and oil companies use design as one of the major instruments by which unity of identity and standards are maintained, even though sales outlets are in a number of different hands. A company such as McDonald's cannot exercise daily control over every aspect of every franchise around the globe, but uses design not just in products, but also in systematic approaches to preparation, delivery, and environments, as a key tool in establishing and maintaining general standards.

If the overall role of design in organizations is so varied that few general patterns are discernible, and then only dimly, there is if anything even less clarity on the level of the detailed operational management of design. Even in particular product sectors, where companies produce similar products for identical markets, wide variations occur.

The specific history of organizations and the personalities involved is obviously a vital consideration in understanding how design played a role in their activities. Some firms are initially based on an entrepreneurial insight about market opportunities;

others originate in a particular technological innovation. Less frequently, some have founders motivated by a sense of social responsibility, others are even established by designers wishing to retain control over essential aspects of their work. Some have had formalized procedures bringing consistency over long periods. Others, however, depend on the personal insights and inclinations of particular individuals in influential positions who believe design is crucial to their company's identity and reputation.

There is no clear pattern in how companies reach the point where design consciousness emerges and becomes incorporated into the battery of competencies considered vital for corporate survival. With some—Sony is a good example—that emphasis on high standards in product forms and communications has been present from its earliest years. In other instances it was generated as a response to crisis, demonstrating that design can play a role in changing the fortunes of companies. The smallest of the Big Three American automobile manufacturers, Chrysler, came back from a deep crisis with a range of vehicles in the early 1990s that were the most innovative to emerge from Detroit for some time. This was in substantial part due to the fact that its talented Vice-President for Design, Tom Gale, was able to function at the strategic level of corporate decision making and make new design concepts part of the overall corporate plan for reviving its fortunes. In many companies, in contrast, it seems that an

understanding of design has yet to penetrate corporate decision making.

If patterns in the evolution of design in corporate consciousness are difficult to explain, how design loses its role in organizations is somewhat clearer. Even when a company can be considered exemplary in its design consciousness, there is no guarantee, as with Olivetti, that design will survive a major corporate crisis resulting from a failure to adapt to changing conditions of one kind or another. A change of management style and consciousness can also mean that carefully nurtured design competencies become dispersed and will no longer be considered as relevant; or there may be a clash of personalities, which seems to have happened at Chrysler after its merger with Daimler-Benz. Recently, some companies have exemplified a trend for design to be 'outsourced'—the jargon term describing a process of cost saving by relying on outside consultants instead of in-house design resources. Even companies that have a strong record of integrating design into their structures and procedures, such as Philips and Siemens, now require their design groups to function as internal consultants. This means they have to compete for corporate projects against external consultancies and are also expected to take on work outside the company in order to remain financially viable.

The trend for design groups to be divested may save money, but

has the disadvantage that, if design is to be something that really distinguishes a company against its competitors, on something more a passing, superficial level, it requires consistent nurturing as something capable of delivering unique ideas. In this respect, the Finnish company Nokia, manufacturing telecommunications products, has consistently used design, often in subtle ways, to distinguish the usability of its products, and this has played an important role in enabling it in less than a decade to challenge established corporate giants in the field, such as Eriksson and Motorola.

Outside the world of large companies are the vast majority of businesses grouped under the general heading of small and medium enterprises (SMEs). These are rarely in a position to dominate markets as large corporations do, and must respond to markets either by moving very nimbly to follow trends, or by using design to create new markets. Italian lighting companies such as Flos and Arteluce, and Danish furniture companies such as Fredericia, have created and sustained niche market leadership, often at the profitable upper levels of markets, through high levels of design innovation in their products.

If formulaic recipes are difficult to discern, however, one decisive factor in smaller companies is clearly apparent: the role played by individual owners in setting standards for design practice. Three examples from different product sectors demonstrate

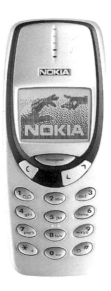

30. Usability and competitiveness: Nokia portable telephone

Contexts

31. Lighting, not lamps: ERCO architectural lighting systems

the potential of SMEs to grow if design is supported and inte-
grated at the highest level. In England, Joe Bamford created JCB,
a company manufacturing back-hoe loaders, used in earth-mov-
ing work, and set design standards that have contributed to his
products sustaining their competitiveness over many years in
world markets with giants such as Caterpillar and Komatsu. In
Germany, ERCO, of Ludenscheid, has been transformed over a
quarter of a century from an undistinguished manufacturer of
domestic lighting fittings to a world leader in the niche market of
architectural lighting. The vision of its Managing Director, Klaus-
Jürgen Maack, brought a new focus on the quality of light as a
deliverable, not the fitting. Any new product from his company
should be a genuine innovation, he insists, with an emphasis on
design in all aspects of his firm's operations. In the USA, a retired
entrepreneur, Sam Farber, noticed older people with arthritic
joints had difficulty in holding kitchen tools. He established a new
company to manufacture a range of kitchen tools, with handles
designed for easy grip and manipulation by a New York consul-
tancy, Smart Design. These have proved to be a remarkable suc-
cess, applicable to a much wider constituency than the elderly,
and, over a decade, Oxo Goodgrips has reconstituted the market
for these products.

Of particular interest are production companies established by
designers to obtain greater control over their work, such as Ingo

175

Contexts

Maurer in Germany, specializing in lighting, and David Mellor in England, designing and manufacturing his own cutlery designs in connection with a substantial retail operation. Perhaps the most outstanding example is James Dyson, whose dual-cyclone vacuum cleaners have toppled the products of major global companies, such as Hoover, Electrolux, and Hitachi, to become market leaders in the United Kingdom, with export markets being continually opened up. Dyson's stated intent to become the largest manufacturer of domestic appliances in the world neatly illustrates the point that big companies were once small companies with ambition.

If businesses are the vital arena of design decision making at the detailed, or micro-design level, many governments around the world have evolved what can be termed macro-design policies for the development and promotion of design as an important factor in national economic planning for industrial competitiveness. Similarly to businesses, governments also demonstrate considerable variations in the structures and practices shaping their policy aims for design. Some even become involved in design practice to promote specific ends, but, even when implementation is left to individual enterprises, the interaction between the two can be a vital element in determining the effectiveness of any national policy. This too, of course, can crucially influence the direction design takes in any particular society.

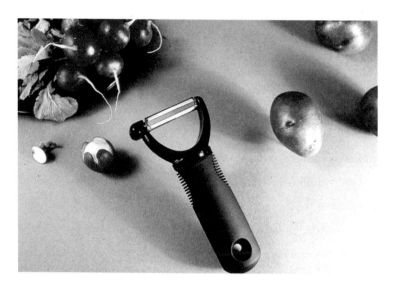

32. Needed by some, appeal for all: Oxo Goodgrips tools—'Y' peeler

Contexts

A government policy can be understood as a set of principles, purposes, and procedures about its intentions on a particular topic. In addition to explicit statements embedded in formal policy documents, however, implicit aspects of how policies are executed can also be highly relevant factors in understanding their effectiveness. In Japan, for example, there is a close informal network of contact and communication between government officials and business executives which is a powerful channel for exchange of ideas and cooperation.

Governments of many kinds have long included design as an element of their economic and trade objectives, though how this functions depends upon the nature of the government and its aims. Does it seek to exercise direct influence over industry, or even, as under Communist regimes, to own the means of production and distribution? Or, as in more democratic regimes, is there an effort to frame broad objectives and rely on cooperation with, or incentives for, industry to carry them out?

Intervention in economic affairs by governments was in the past most frequently directed to preventing innovation when it threatened government interests or was likely to cause social disruption. A significant change in the eighteenth century in Europe, however, saw the flowering of an economic policy known as mercantilism. Briefly, this was an effort to restrict imports and promote exports to enhance relative economic performance. First

systematically formulated in France under Louis XIV, the means used to promote these ends included: incentives to stimulate the development of manufacturing at home; direct investment in production facilities; sheltering domestic producers from foreign competition by high protectionist tariffs; supporting merchant capitalists in competition overseas; investing in infrastructure and manufacturing capabilities; attracting talented craftsmen from other countries; and developing design education opportunities.

Underpinning mercantilism was a concept of an essentially static economy: since the volume of production and commerce possible at any time is considered to be limited in total amount, the commercial policy of a nation should target obtaining the biggest slice of the available pie at the expense of other nations. In this situation, design was considered a decisive factor in creating competitive advantage and by such policies France became a leader in the manufacture of luxury products, a position it holds to this day.

Fundamental to mercantilism, and any present-day government design policy, is the belief that states should act in economic matters in terms of their self-interest. This belief still endures and, despite the growth of regional groupings such as the European Union and the North American Free Trade Area, derivatives of mercantilism are still a powerful force in the policies of many governments, albeit in modified form. The emphasis is now

on promoting technology and design as a means of gaining economic advantage by enhancing national competitiveness. The belief that these capabilities can be defined in national terms and promoted within the boundaries of a state as a national characteristic is increasingly a questionable assumption.

In European countries, design policy has generally been in the form of promotional bodies funded by governments but having considerable leeway in the details of how they function. This pattern first clearly evolved in the United Kingdom, which has one of the oldest legacies of design policy. When the UK opened up a substantial technological and economic lead as a consequence of the Industrial Revolution, French products still competed effectively based on superior pattern designs. As a result of recommendations by the Select Committee on Design and Manufacture established by Parliament in 1835 to address these problems, new design schools were established. A problem, however, was the belief that design in industry required an injection of art to effect improvement. Moreover, the only people capable of teaching in the new schools were artists. So the schools in fact evolved as art schools, and indeed the first of them, the Normal School of Design, was subsequently renamed the Royal College of Art. Continuing complaints by manufacturers of the resulting deficiencies of the system in supplying trained designers echoed across succeeding decades, resulting in other efforts to make

design education better serve the needs of industry, which gener-
ally proved fruitless.

In the final stages of the Second World War, in 1944, the UK
government established the Council of Industrial Design, later to
be renamed the Design Council. Although financed by govern-
ment, it functioned as a semi-independent organization, with the
primary aim of promoting design in industry as a means of stim-
ulating exports. In this original aim it must be judged a complete
failure, since, forty years later, the UK balance of trade in manu-
factured goods went into deficit for the first time in two cen-
turies. For much of its existence, the Design Council sought to
function by persuasion and, as a result, had little power to alter
anything significantly. Since 1995, it has been a slimmed-down
body, showing great energy in promoting design as an element of
government efforts to encourage innovation in industry. The
United Kingdom still has a substantial trade deficit in manufac-
tured goods, however, so much still remains to be done.

The German equivalent of the Design Council, the *Rat für
Formgebung*, was founded in 1951 and similarly supported by gov-
ernment finance, in this case federal and state sources. For a time
it played a substantial role in promoting design in industry and to
the public at large, emphasizing not only an economic but also a
cultural role for design in modern society. By the 1980s, howev-
er, funding had dwindled, and, although it continued its work in

reduced circumstances, the main emphasis in promotional work switched to various design centres in the federal states, which emphasized regional developments.

An obvious problem with such bodies is that they are subject to sometimes fickle changes in the political climate. The Netherlands Design Institute, founded in 1993 and funded by the Dutch government, became, under the Directorship of John Thackara, one of the most dynamic focal points anywhere for debate and initiatives about the role of design in modern society. In December 2000, however, it closed, after funding was withdrawn on the recommendation of the Minister of Culture. Clearly, when a gulf of any kind opens up between how this kind of institution functions and politicians' perception of what it should be, the latter have decisive power.

In terms of such relationships, one of the most consistently successful European promotional bodies has been the Danish Design Council. Established after the end of the Second World War, it has been an integral element in establishing design, not just as a factor in Danish economic life, but as part of the dialogue about the nature of Danish society. This would have been impossible without the ongoing support of the government, which was evident in a new purpose-built Danish Design Centre that opened in the heart of Copenhagen in early 2000 and is a remarkable testament to a vision of design being seamlessly integrated into national life.

33. Design as state policy: the Danish Design Council

Contexts

In contrast, across the Atlantic, it is a curious fact that the USA does not have, and never has had, a design policy. Proposals aplenty have been generated by interested parties such as professional design organizations, but the Federal government remains impervious to such a project and only the states of Michigan and Minnesota have shown any interest in design as competence to enhance competitiveness. The reasons for this situation are complex, but in part lie in an economic mindset that regards design as something superficial, that can easily be copied by foreign competitors, and should not therefore be the recipient of government support.

Ironically, the development of design as a business tool in interwar America served as an example for Japan when embarking on a programme of economic reconstruction following the Second World War. The key government body responsible for Japan's industrial development policies is the Ministry of International Trade and Industry (MITI). Its policies set out to coordinate the activities of Japanese firms within specified sectors and so make them competitive in international markets. How Japan developed its design competencies as part of this effort is an archetypal model of how MITI functions. In fact, the Japanese approach is one of the clearest examples that modern variants of mercantilist principles are still thriving.

To the extent that design expertise in Japanese industry exist-

ed before the Second World War, it derived from European artistic or craft-based concepts. Japan was largely regarded as a country that turned out cheap imitations of foreign products. After defeat in the war left Japan's industrial capacity largely in ruins, MITI developed plans for reconstruction and economic expansion based on exports. Its early policies had two main planks: introducing the latest foreign technology; and protecting domestic industry while it rebuilt. The home market was viewed as a developmental springboard for exports.

As part of this policy, MITI began vigorously to promote design, inviting advisory groups of prominent designers from abroad, but, most significantly, sending groups of young, talented people to be trained in the USA and Europe, to create a cadre of qualified designers. Design promotion activities were stimulated by establishing the Japan Industrial Design Promotion Organization (JIDPO) as a branch of MITI and the 'The Good Design Products Selection System', better known as the 'G-Mark' competition, to promote the best Japanese designs.

On the basis of MITI's promotion of design, by the mid-1950s, many larger Japanese companies began to establish design sections and design began to be rapidly absorbed and integrated into development processes. Some new designers returning from overseas were employed in corporate design groups, but others set up independent consultancies, notably Kenji Ekuan's GK

Associates, and Takuo Hirano, who set up Hirano & Associates, which for almost half a century have been leading organizations in establishing the credentials of design in the business community. New educational courses and on-the-job learning led to a sustained expansion, so that, by the early 1990s, there were some 21,000 industrial designers employed in Japan. Despite the economic setbacks of the 1990s, MITI continues to view design as a strategic resource for the national economy, with ongoing policy reviews providing a framework of ideas and responses to new developments. Few people in the world remain unaffected by the shift in Japan from producing imitation goods to generating technically superior, well-designed products. In the process, Japan's economic standing in the world and its own standard of living have dramatically changed.

Other countries in East Asia have followed the Japanese model of design promotion with great success. In Taiwan, the Ministry of Economic Affairs has consistently promoted design, together with technological development, as a means of enhancing the intrinsic value of products in export markets. The body responsible for this policy, the China Export Trade Association, has played a large part in raising the profile of Taiwanese products from their earlier reputation as cheap copies. The twin aims of economic policy for the new century are summed up in a slogan linking technology and design as the basis for the future. So confident

now are the Taiwanese in their products that they are aggressive-
ly carrying their message to their major competitors, having
established Design Promotion Centers in cities such as
Düsseldorf, Milan, and Osaka.

South Korea demonstrates a similar pattern. Devastated by war
following the invasion of North Korea in 1950, the government
set out in the 1960s to emulate the Japanese pattern of industri-
alization. Similarly, companies were encouraged to use designers
to raise the standard and reputation of their products, with design
education and promotion carefully fostered on a foundation of
government funding and support. Like Japan and Taiwan, most
early industrial products were imitations of foreign designs, but
by the 1980s design education facilities in Korea were substantial
and rapidly evolving, and on the level of both corporate and con-
sultant design there was a rising level of achievement.

Other Asian countries such as Singapore, Malaysia, Thailand,
and, more recently, China are similarly promoting design as a
means of increasing their share of international trade. Throughout
Asia this promotion of standards internally has been accompanied
by efforts, both overt and covert, to restrict the penetration of
domestic markets by overseas products.

Many governments evidently believe such policies to be valu-
able, since they continue to pursue them and often underline their
commitment with substantial funding. Shoring up national com-

petencies is often viewed as a buttress against the encroachment of globalization. It should be noted, however, that design consultancy, at its most effective, creative levels, is one of the most fluid capabilities in global patterns of trade irrespective of national boundaries. Encouraging the design sector as a service industry in its own right within a country to function regionally or globally, as in Singapore, could have powerful relevance when compared to narrowly conceived national policies.

In addition, in most countries, the provision of design education is also assumed to be the responsibility of government, though, again, there is no evidence of any proposals to shape design education in significantly new ways to gain a future advantage. On the other hand, serious research into design and its effectiveness is generally conspicuous by its absence, although governments widely sponsor research into many other aspects of business performance, such as technology and competitiveness.

Another striking fact is that design in the modern, professional sense seems to evolve at a particular point and level of affluence in countries' economic and technological development. Examples of design being used strategically at a national level to help build up an undeveloped economy are conspicuous by their absence yet could potentially be a constructive tool for benefit in emerging or Third World economies.

A fourth contextual level of particular relevance could be

cited: that of how design is understood by the broad public that its outcomes so widely and profoundly influence. How design is depicted in the media, the level of discussion of its relevance and contribution to economic and cultural life, how people think about their role in its use and application, are some aspects that serve as indicators in this context. The messages are either extremely confusing, however, or conspicuous by their absence. Since so much design in the twentieth century was determined by the perceptions of producers and what they decided users should have, it is hardly surprising that there are vast amounts of market data available, but little understanding of what people really think about design. In no other aspect is there a greater need for research to establish some clear indicators of how design is understood.

10 Futures

Two themes have recurred throughout this book: the extent of variations in design practice, and the manner in which it is being affected by far-reaching changes in technology, markets, and cultures. Design cannot remain isolated from these wider patterns, but the situation is confused. As in previous historical phases of change, a point arrives at which consciousness of the extent of change becomes a pressing issue, but uncertainty about what will eventuate means few definitive answers are available. Since the early 1980s, attempts to adapt old forms and processes to new purposes have been juxtaposed with wild experiments and many overconfident pronouncements of what the future will be. If the basic proposition in this book is that design has evolved historically in a layered pattern, rather than a linear evolution in which new developments eliminate previous manifestations, then we can expect new layers to be added that will alter the role and relationships of pre-existing modes.

Certainly, at one level, existing methods and concepts of design, especially those that emerged predominantly over the twentieth century, are continuing to evolve. Mass production is entering a new phase with its extension to global markets on the basis of sophisticated systemic concepts, as discussed in Chapter

8. It is already clear that computers have had a profound, transformative influence as a tool in design, extensively supplementing and enhancing, although not always replacing, existing means of conceptualization, representation, and specification. The use of giant computer screens enabling work to be processed in enormous detail, concurrently on several sites, together with virtual-reality representations, is widely replacing older methods of renderings and physical models as a means of developing concepts for production. Yet at the same time, in a typical pattern of juxta-position, one of the most ancient means of exploring and representing visual ideas, drawing, remains an irreplaceable skill for any designer. Another procedure of enormous influence is the refinement of rapid prototyping machines, capable of generating from computer specifications three-dimensional forms of ever-increasing size and complexity in ever-shorter periods of time. Computers also provide the capability to combine and layer forms from multiple sources—text, photographs, sound, and video—to effect huge transformations in two-dimensional imagery. Design is simultaneously becoming more specialized in some respects, with more detailed skills in specific areas of application, and more generalist ones in others, with hybrid forms of practice emerging in parallel.

There are already sharp differences in the levels at which designers function within organizations, which can be expected

to widen. Some are executants, carrying out ideas essentially determined by others, and even here, their work can be differentiated between routine variations in the features of products or the layouts of communications, on the one hand, and highly original redefinitions of function and form on the other. According to the type of business a company is in and the life-cycle phase of its products, designers may variously be involved in imitation, the adaptation of incremental features, major redefinitions of functions, or the origination of profoundly new concepts. They are also increasingly finding their way into executive functions of decision making at strategic levels that fundamentally affect not just the future shape of forms, but the future form of businesses in their entirety. Sony Corporation, for example, has a Strategic Design Group, reporting to its President, with a wide-ranging remit of charting possible futures for Sony. Behind such developments is the question of whether design is valued primarily in terms of a particular set of skills related to existing products or services, or is also considered as a distinct form of knowledge and insight capable of creating wholly new concepts of value.

On another plane is the difference between whether designers function as form-givers, determining form in a manner that allows no variation—it is either accepted or not—or as enablers, using the possibilities of information technology and powerful minia-

turized systems to provide the means for users to adapt forms and systems to their own purposes. The growth of electronic technology, the manufacture of powerful microchips, and the generation of more sophisticated software at commodity prices mean that products and systems have the potential to be highly flexible in response to specific users' needs. Both roles, of form-giver and of enabler, will continue to be necessary, but the distinction between them is based on fundamentally different values and approaches, to a point where they constitute substantially different modes of practice.

More elaborate techniques and methodologies will undoubtedly emerge, particularly in larger, systemic approaches, but, as the tools become more powerful, it becomes necessary to raise the all-important question of the values informing design practice. Will the future pattern of what is produced, and why, continue to be primarily determined by commercial companies, with designers identifying with their values; or by users, with designers and corporations serving their needs? There is much free-market ideology claiming the latter to be the case, but the realities of economic practice make it plain that in many respects the former still dominates. Consider, for example, the number of telephone tree systems that begin by informing callers how important their call is, before leading into an infuriating electronic labyrinth of confusion and non-responsiveness, with no link to a human being. The

gulf between image and reality in the commercial world is nowhere more evident than in how customers are treated. There is increasingly an inherent tension between, on the one hand, producers trying to control markets, and, on the other hand, the access to information and control potentially made available to users by new technologies. Any resolution will in most cases not be made by designers, but design will be a vital element in expressing the outcomes.

The question of which population designers address in their work is therefore fundamental. The basic needs of the small percentage of the world's population in industrialized countries have been largely met. Most people have adequate diet and living standards, and access to health and education in conditions of considerable freedom. The benefits in terms of openness of life choices, and access to education and information, are substantial. Freedom of access to information and increasing levels of customized products for a majority of the population, both using well-designed interactive sites, are among the benefits evident in the USA, which leads the world in levels of computer ownership and access. It is not certain, however, that the rest of the world will simply follow the US pattern. Already, China has a 'firewall' preventing its citizens from having access to web sites outside its borders. The design of systems can be used equally for purposes that can enhance or restrict freedom of information.

Poverty is a relative term, moreover, and there are still many problems in industrialized countries that increasingly require attention, to which design can potentially contribute, such as improving educational provision for the poor and unskilled (in the USA and the United Kingdom, around a quarter of the population is functionally illiterate); mitigating the problems of unemployment by creating opportunities to retrain frequently in a constantly changing economic climate; addressing the needs of ageing populations; creating more flexible welfare and medical provision; and addressing environmental questions, not just large ecological concerns, but more immediate problems such as noise pollution and stress in human environments.

Such problems can frequently be glossed over in markets dominated by excess wealth, with conspicuous consumption becoming endemic. In the context of the USA, where it was estimated in the year 2000 that 3 per cent of the world's population consumed 25 per cent of available world resources, there has been a growing emphasis on designing not just products and communications, but 'experiences'. This can in part be seen as an indicator that basic utility is something taken for granted. It also suggests that life is so meaningless for people incapable of experiencing anything for themselves that they have to be supplied with a constant flow of artificial, commercialized, and commodified experiences that take on their own reality. Design in this context becomes the

provider of bromides to block out anything demanding or uncomfortable.

The growth of globalization and industrial development and urbanization in the so-called 'Third World', in 'Developing' or 'Peripheral' countries— accounting for some 90 per cent of the world's population—also raises pressing questions regarding the economic and cultural role of design. Some global corporations have 'hollowed out' their workforce in their home country, maintaining only core management and design functions, while transferring production to wherever a source of cheap labour exists, showing little sensitivity to the diversity of local cultures they affect in the process. Sweeping assertions in corporate circles that with globalization the role of national governments is increasingly irrelevant sounds suspiciously like wishful thinking. Outside the small number of industrially advanced countries, government may be the one institution capable of resisting the more predatory aspects of commercial expansion and cultural encroachment, which can in any case originate equally from within their borders as from outside. Unfortunately, in practice, there are too many governments, themselves based on corrupt instincts, that are willing allies in such exploitation.

The processes of globalization, however, should not simply be depicted as a juggernaut of large corporations taking over the world, as seems to be the case in the wave of protests against such

bodies as the World Bank and the World Trade Organization. Innumerable small and medium companies are increasingly involved in global trade, representing a very broad spectrum of products and services that cannot be depicted in terms of crude stereotypes of capitalism.

Many examples can indeed be found of smaller commercial companies with a sense of responsibility to their users. The Finnish company Fiskars transformed the design and manufacture of an existing product, scissors, by basing its whole approach on careful ergonomic studies of use in practice, with the aim of making each product safe and efficient for its specific task. So successful was this approach that the company subsequently extended it to other product categories, such as garden tools and axes. Such developments do demonstrate, however, that commercial success can be based on design being used in a manner compatible with social values.

Idealistic claims by designers, however, that in some innate manner they represent the standpoint of users is clearly unsustainable, especially given the number of designers servicing the needs of conspicuous consumption in wealthy societies, while basic needs around the globe remain unsatisfied or not even addressed. Yet there are indicators, small but hopeful, of what is capable of being achieved when the problems of developing areas are understood and addressed. One such is the clockwork radio

concept of Trevor Bayliss, intended to give rural communities in southern Africa who lack electricity supply access to government information on how to combat AIDs. In Chile, two young designers, Angelo Garay and Andrea Humeres, conceived of packaging for light bulbs, which is normally discarded, to be adaptable for use as a light shade in poor homes where bare bulbs are the norm. More such small-scale tangible design solutions could have an enormous cumulative impact if more companies understood that their own self-interest, in terms of the necessary profitability for survival, could be better advanced by close attention to customers' and potential customers' need. A creative solution for a specific problem, based on particular local needs, can frequently have innumerable applications in other locales and for other purposes. Bayliss's clockwork device to power a small radio, for example, has been adapted for use in electric torches.

Although huge commercial potential exists in meeting user needs, a nagging question recurs: if basic requirements become more completely satisfied, will the whole world turn to conspicuous consumption, and with what consequences? In this sense, design is not simply an activity whose course will be charted by practitioners, but an expression of what societies believe to be quality of life on a sustainable basis. Designers cannot provide the whole solution, but should be part of the debate.

Futures

In considering the role of design in the future, therefore, a major question requiring an answer is whether designers will be merely technocrats, devoting their skills to the highest commercial bidder without consideration of the ends they serve. Or is there instead a dimension of social and environmental purpose requiring acknowledgement in their work? How much remains ignored, even in the most basic aspects of advanced societies, was dramatically evident in the US presidential election of November 2000, when the design of electoral forms and the devices processing them were clearly inadequate in communicating to all citizens what their choices in voting were, revealing a lack of feedback to confirm voting choices, and giving no opportunity to change a mistake. Discussion of solutions has predominantly rested on consideration of hardware and its cost. If bank ATMs were equally as inadequate in their procedures, there would be a huge outcry, but it seems that acknowledging democratic rights does not carry the same weight as commercial functions.

If technology is indeed to be humanized, and its benefits brought to increasing numbers of people around the planet, it is necessary to recognize that it is designers who determine the detailed interfaces in all their forms that implement technology in everyday life. To what extent the values their designs embody will be primarily intended to generate profits, serve people, or harmonize with ecological concerns, and whether all can be com-

bined in some kind of viable commercial balance, are matters of no small importance.

To answer such questions, and many others of significance, requires as a precondition that design be understood as a decisive factor shaping all our lives, all the time. There are few corners of our environment, or aspects of the objects and communications enveloping us, that could not be significantly improved on some level in greater or lesser degree. Only when we understand that all these manifestations of design are the outcome of choices, ostensibly made on our behalf, but in most cases without our involvement, can the meaning of design in the contemporary world change. Only when it is adequately understood, debated, and determined as something vital to everyone will the full potential of this human capacity begin to be realized.

Further Reading

The problems discussed in the opening chapter of this book regarding the meaning of the word 'design' are amply evident in available works published under this rubric. There is a dearth of general introductions to design that give any kind of overview of the spectrum of activity it covers; instead, there is an abundance of works on the style of places, usually emphasizing interior furnishings and fittings for those with surplus income, with books on historical period styles following the pattern of art historical categories also providing rich fare. Such books have value in developing a visual vocabulary, but only rarely explore the nature of processes or design thinking.

Perhaps the area with the greatest number of publications is design history, although here there tends to be a dominant focus on the nineteenth century onwards. However, Philip B. Meggs, *A History of Graphic Design* (New York: John Wiley & Sons, revised 3rd edition, 1998), is a useful reference text and an exception in tracing the origins of his subject from early societies. A good collection of essays exploring the social significance of graphic design is Steven Heller and Georgette Ballance (eds.), *Graphic Design History* (New York: Allworth Press, 2001). On environments, John Pile, *A History of Interior Design* (New York: John Wiley & Sons, 2000), is a sound introductory history, while Witold Rybczynski, *Home: A Short History of an Idea* (New York: Viking, 1986), is a very approachable and fascinating discussion of many aspects of home design and furnishing. For products, my own *Industrial Design*

Further Reading

(London: Thames & Hudson, 1980) surveys the evolution of this form of practice since the Industrial Revolution, although the later chapters are somewhat dated. There are several general historical texts. One of the best is Adrian Forty, *Objects of Desire: Design and Society Since 1750* (London: Thames & Hudson, revised edition, 1992), with an emphasis on the emergence of modern consumer culture. Penny Sparke, *A Century of Design: Design Pioneers of the 20th Century* (London: Mitchell Beazley, 1998), is strong on furniture design; Jonathan M. Woodham, *Twentieth Century Design* (Oxford: Oxford University Press, 1997), treats design as an expression of social structures; Peter Dormer, *Design since 1945* (London: Thames & Hudson, 1993), is a general overview of post-war developments with an emphasis on craft design; and Catherine McDermott, *Design Museum: 20th Century Design* (London: Carlton Books, 1998), is based on the collection of the museum.

Design practice is also not well served. Quite a few books on this aspect can be described as design hagiology, essentially uncritical forms of promotion for designers and design groups to establish their position in a pantheon of classic work. An account of work at one of the world's leading consultancies, which generally avoids such pitfalls, is Tom Kelley, *The Art of Innovation: Lessons in Creativity from Ideo, America's Leading Design Firm* (New York: Doubleday, 2001). The work of a design group in a global manufacturing company is presented in Paul Kunkel, *Digital Dreams: The Work of the Sony Design Center* (New York: Universe Publishers, 1999), a profusely illustrated examination of projects by Sony design groups from around the world. A volume published by the Industrial Designers Society of America, *Design Secrets: Products: 50 Real-Life Projects Uncovered* (Gloucester, Mass.: Rockport Publishers, 2001), stresses the processes of design, rather than the end products, and discusses and illustrates fifty examples of projects from start to finish.

Peter Wildbur and Michael Burke, *Information Graphics: Innovative Solutions in Contemporary Design* (London: Thames & Hudson, 1999), uses numerous well-illustrated cases to make a good introduction to this specialist form of communication. Some interesting new ideas on design for working environments are explored in Paola Antonelli (ed.), *Workspheres: Design and Contemporary Work Styles* (New York: Harry N. Abrams, 2001), a catalogue of an exhibition on this theme at the Museum of Modern Art in New York. A partner in a London consultancy, Wally Olins, presents his arguments that corporate identity is as much about creating a sense of unity within companies as affecting prospective purchasers in *Corporate Identity: Making Business Strategy Visible through Design* (Boston: Harvard Business School Press, 1992). As a sourcebook, some 200 examples of recent identity design at a range of levels and complexity are presented in David E. Carter (ed.), *Big Book of Corporate Identity Design* (New York: Hearst Book International, 2001). An interesting comparison with similar German practice can be made by reference to a series of yearbooks, Alex Buck and Frank G. Kurzhals (eds.), *Brand Aesthetics* (Frankfurt-am-Main: Verlag form), the first of which appeared in 1999.

The roles objects play in people's lives have not been explored in any great depth from a design standpoint, but there are useful texts treating this aspect from a variety of other disciplinary perspectives. Mary Douglas, a noted anthropologist, and an economist, Baron Isherwood, emphasized goods as instruments of contemporary culture in *The World of Goods: Towards an Anthropology of Consumption* (London: Routledge, revised edition, 1996). Sociological research was the basis of *The Meaning of Things: Domestic Symbols and the Self* by Mihaly Csikszentmihalyi and Eugene Rochberg-Halton (Cambridge: Cambridge University Press, 1981), which demonstrated how people

construct personal patterns of meaning from the objects surrounding them. Donald A. Norman, *The Design of Everyday Things* (New York: Currency/Doubleday, revised edition, 1990), written from a psychological standpoint, is still an excellent introduction to basic issues of user-centred design in everyday objects, although some of the cases are dated. Some interesting ideas on the dependence of technological innovation to social context are found in Wiebe Bijker, Thomas P. Hughes, and Trevor Pinch, *The Social Construction of Technological Systems* (Cambridge, Mass.: MIT Press, 1987).

Jeremy Aynsley, *Nationalism and Internationalism: Design in the 20th Century* (London: Victoria and Albert Museum, 1993), is a short introduction to the broader interplay between the global and the local. In general, however, the role of government in promoting design is a theme awaiting substantial research and publication. My own essay on the development of Japanese government policy as part of its economic strategy to rebuild its economy after the Second World War can be found in John Zukowsky (ed.) with Naomi R. Pollock and Tetsuyuki Hirano, *Japan 2000: Architecture and Design for the Japanese Public* (New York: Prestel, 1998). A good example of how themes in design can be publicized by a national design promotion organization is the series of small books published by the Danish Design Council in Copenhagen. Its web site (www.design.dk/org/ddc/index_en.htm) is also worth a visit, while that of the Design Council of the United Kingdom (www.design-council.org.uk/) contains much interesting material, including publications and reports that in some cases can be downloaded.

The principles of business aspects of design were well described in Christopher Lorenz, *The Design Dimension: The New Competitive Weapon for Product Strategy and Global Marketing* (Oxford: Blackwell, 1990),

although the case studies used are now dated. One of the best collections of examples of the role of design in corporate strategy can be found in John Thackara, *Winners!: How Today's Successful Companies Innovate by Design* (Aldershot: Gower Press, 1997). Approaches to the management of design are well covered in Rachel Cooper and Mike Press, *Design Management: Managing Design* (Chichester: Wiley, 1995). Insights into the practical problems of managing design in large corporations, based on his experience at Hermann Miller & Philips, are provided by Robert Blaich with Janet Blaich, *Product Design and Corporate Strategy: Managing the Connection for Competitive Advantage* (New York: McGraw-Hill, 1993). A heart-warming account of the struggles of designer-entrepreneur James Dyson to bring his new concept of a vacuum cleaner to market can be found in his *Against the Odds: An Autobiography* (London: Trafalgar Square, 1998).

On the subject of how design needs to adapt in the future, and the purposes it should serve, there are some interesting views in a volume of short texts by Gui Bonsiepe, one of the most profound thinkers about the role of design in the changing circumstances of our age, collected under the title *Interface: An Approach to Design* (Maastricht: Jan van Eyck Akademie, 1999). One of the best books on the dilemmas presented by the profound changes in technology taking place is *The Social Life of Information* by John Seely Brown and Paul Duguid (Boston: Harvard Business School Press, 2000). Technological solutions alone are inadequate, the authors argue, and, if designers are to make them comprehensible and useful, the human and social consequences need to be understood and incorporated into their work.

Index

Index

Index

Picture Acknowlegement

1 © Staffan Widstrand/Bruce Coleman Collection
2 © Corbis
3 © Courtesy Belgian Tourist Office
4 © Partridge Fine Arts, London/The Bridgeman Art Library
5 © Museum fur Kunst und Gewerbe, Hamburg
6 © Ludvigsen Library
7 © The author
8 © AutoExpress
9 © Courtesy Modus Publicity
10 © Courtesy archive.pg/Siemens
11 © National Motor Museum, Beaulieu
12 © OUP
13 © Apple
14 © Herman Miller/www. hermanmiller.com/europe
15 © Corbis
16 © 1976 by ERCO Leuchten GmbH
17 Courtesy Amazon
18 © Gary Russ/Image Bank © Michael Freeman/Corbis
19 Courtesy TBWA.Chiat/Day
20 © Joel W. Rogers/Corbis
21 Courtesy Niketown Chicago
22 © Corbis
23 © BT Corporate Picture Library
24 Courtesy Landor Associates
25 © Topham/FNP
26 Courtesy DTLR
27 © London Transport Museum
28 © Corbis
29 Courtesy Siematic UK
30 Courtesy Nokia
31 Courtesy ERCO
32 Courtesy OXO International
33 © Danish Design Council books